IMAGES
of America

DULUTH

IMAGES
of America

DULUTH

S. Lorraine Norwood

ARCADIA
PUBLISHING

Published by Arcadia Publishing
Charleston, South Carolina

Printed in the United States of America

Library of Congress Control Number: 2010941661

For all general information, please contact Arcadia Publishing:
Telephone 843-853-2070
Fax 843-853-0044
E-mail sales@arcadiapublishing.com
For customer service and orders:
Toll-Free 1-888-313-2665

Visit us on the Internet at www.arcadiapublishing.com

*This book is dedicated to Kathryn Parsons Willis, whose generosity
made this work possible. Kathryn's lifelong devotion to Duluth
and her enthusiasm for its history make her a most valuable
treasure in the community. I am especially indebted to her for
the box of wonderful photographs of the Joan Glancy Clinic and
Hospital. Kathryn's gracious attitude was even more special given
the fact that I approached her during the Christmas season, the
busiest period for her lovely store in Cumming, Georgia.*

CONTENTS

ACKNOWLEDGMENTS

Many people in Gwinnett County helped bring this book to fruition. A special note of gratitude goes to Bill Baughman and his volunteer staff at the Gwinnett Historical Society who provided photographs and information with enthusiasm and courtesy. I am also indebted to the following citizens or former citizens of Duluth who showed enthusiasm for the project by taking the time to talk to me and providing photographs: June Hawkins, Kristin McGregor, Teresa Lynn, Chris McGahee, Paul Kesmodel, Michael Brown, Jimmy Martin, Cecil Martin, Joe McKelvey, Curtis Franklin, Mary Lail, Judy Ann Wilson, Jeanne Hall, Pastor Ronald Bowen, and Mrs. Gerald Baker.

In addition, a special thank you goes to Howell Medders of the University of Arkansas Department of Agriculture for the use of photographs from his article "The Chicken of Tomorrow;" Ginger Powell of the Gwinnett Medical Center; and Steve Engerrand and Gail DeLoach from the Georgia Archives. Gail, especially, went above and beyond in one of the worst snow and ice storms in Georgia's history. A special note of gratitude is extended to Joanne Bryan, Jennifer Burns, Jenny McLean, and Nancy McReynolds for taking on a brutal workload so that I could finish this book. And finally, a thank you goes to my editor, Brinkley Taliaferro, for her expert guidance and for keeping me on track.

All photographs noted as GWN or GEO can be found in the Vanishing Georgia Collection in the Georgia Archives. They are referenced as GWN ### or GEO ### in each caption and are included courtesy of the Georgia State Archives, Vanishing Georgia Collection. All photographs noted as GHS are from the Gwinnett Historical Society. All photographs noted as CoD are from the City of Duluth.

INTRODUCTION

In the early 1800s, Cherokee Indian territory extended to what is now the town of Duluth, Georgia. Native Americans used the area as a gateway to the Chattahoochee River Valley and hunting grounds below the Fall Line. There were no white settlers here, but in 1818, the General Assembly of Georgia opened the area to pioneers, who packed their valuables and rode horses or walked west in search of a new life. Settlers determined to farm the land, run a business, or provide legal and medical services soon followed. One of those settlers was Evan Howell, a North Carolina native who brought his family south because he saw an opportunity for advancement. A businessman and farmer, Howell settled on 2,000 acres of rich bottom land near the Chattahoochee River, where he built his home and established himself as a planter and merchant. Howell had been crippled as a youth and miraculously cured. Perhaps he never forgot those days of disability, for he loved to dance and often held parties at his plantation house.

Knowing that settlers needed supplies, Howell opened a general store. Then, realizing there was no way to cross the Chattahoochee River easily, he established a ferry to take passengers and freight from one side of the river to the other. He also saw the need for new roads. Peachtree Road, an offshoot of an old Indian trail that ran north–south, had been surveyed and constructed during the War of 1812, connecting Fort Daniel with the fort at Standing Peachtree 30 miles away. Howell obtained permission in February 1833 to construct a road from the Chattahoochee River across his land to intersect Peachtree Road. This intersection became known as Howell's Cross Roads. The intersection still exists, although today it is known as Main Street and West Lawrenceville Street. For the next few decades, Howell's Cross Roads grew very little. There was some commercial activity, but the town remained a sleepy rural community.

During the Civil War, major battles occurred in Atlanta to the south and Kennesaw to the west, but Howell's Cross Roads was untouched aside from the economic devastation that followed the war. Large plantation owners in the area were ruined financially and their landholdings fragmented into small farms. The town might have remained a sleepy backwater or disappeared entirely except for a major event that changed Howell's Cross Roads forever. In 1871, railroad tracks were constructed through Howell's Cross Roads, and economic prosperity followed. Evan Howell's grandson, at the dedication of the new passenger depot, renamed the town Duluth. The name referred to a ruckus that was taking place in Congress about a bill seeking money for a railroad that would end in an obscure town named Duluth, Minnesota. Howell evidently thought it would be amusing to poke fun at congressmen by giving another obscure town the Duluth moniker.

When the first train came roaring down the track, Duluth residents, many of whom had never seen a train before, were amazed at its speed and power. With the railroad came new prosperity and growth. A passenger depot was built to serve patrons traveling by train, while a freight depot handled the goods coming in and out of town. Meeting "the Belle," a passenger train, was a popular pastime giving onlookers a chance to see who might be coming to town and who might be embarking on a trip.

The Methodist church formed in Duluth soon after the installation of the railroad. It was followed by the Baptist church in 1886. Attending church in Duluth was a form of entertainment. The first public school was built in the 1870s, a two-room schoolhouse that was replaced by a larger brick structure in 1907.

With the rise of cotton farming, the town soon found itself covered in cotton bales from one end of Main Street to the other. Farmers hauled cotton by the wagonload to where it was ginned, baled, and stored in warehouses until it could be shipped to textile mills. Soon the town could boast of several dry goods stores, a blacksmith shop, three cotton gins, a saloon, banks, a post office, a hotel, and a funeral home.

Sometimes, those who came to town had a little too much fun and were whisked away to the Calaboose to sleep it off. If the Calaboose was too full on Saturday nights, miscreants were taken

to empty boxcars, where they were kept until the following morning. The Calaboose still stands today in Duluth, a reminder of the town's rough-and-tumble days.

In the 1920s, the local economy slumped. Cotton, once the lifeblood of the community, was hard hit by the boll weevil infestation. The town deteriorated economically, and according to Alice Harrell Strickland, the wife of a local lawyer, it was deteriorating morally. Determined to rid the town of demon rum, Strickland ran for mayor and won, becoming Georgia's first female mayor in 1922.

In the 1940s, Duluth residents rallied to build a hospital to meet the needs of its own residents and others living in a three-county area. The hospital was featured in a national magazine and proved inspiring to the entire nation. The hospital was a harbinger of things to come in Duluth, where industry, commerce, and development have once again brought a wave of settlers looking to advance themselves. The first wave came in the 1960s, as the mushrooming of Atlanta attracted new professionals to the area. The second wave has now brought a multicultural flavor to the city and its environs. Duluth celebrates its heritage every year with a festival in the old part of town and on the new town green, where longtime residents and newcomers can mingle and enjoy the rebirth of an old cotton town in the 21st century.

The following song lyrics were written for the Fall Festival in 1988. Words and music are by Jimmy Martin and Charlie Wynn.

"I Love Duluth"

Hello neighbors! How do you do!
It's just fine living in Duluth.
It's such a friendly place,
Everybody's got a smile on their face.
We're just happy living in Duluth.

Old-timers tell about the days of the cotton gin,
How Duluth was the hub for the cotton coming in.
How the grand Southern Belle rode on through Duluth,
How the catfishin' was fine in the mighty Chattyhooch.

I love Duluth, friends,
I love Duluth.
If you come here you'd love her, too.
It's such a friendly place,
Everybody's got a smile on their face,
We're just happy living in Duluth.

Duluth 's a little town right off I-85,
From hot Atlanta it's a 20 minute drive.
It's the home of the Wildcats and hospitality.
For a great place to live,
Duluth's the place to be.

I love Duluth, friends,
I love Duluth.
If you come here you'd love her too.
It's such a friendly place,
Everybody's got a smile on their face.
We're just happy living in Duluth.
We're just happy living in Duluth.

One

THE RAILROAD YEARS

Evan Howell's family was soon joined by other settlers whose names became integral to the history of Duluth—the Knoxes, Parsons, Dodsons, Dodds, Taylors, Findleys, McClures, McDaniels, McGees, Rutledges, Lowes, Barkers, Cooks, Wares, Wilsons, Littles, Summerours, Jones, Pittards, and Stricklands. In the 1870s, townspeople learned the exciting news that the Atlanta-to-Richmond railroad would come through town. Howell's grandson was asked to change the town's name to something befitting its newfound importance. At a dedication of the town's handsome railroad depot in 1871, Howell declared that Howell's Cross Roads would now be known as Duluth. The name was a humorous reference to a fractious argument in Congress that involved a bill to finance a section of railroad in Minnesota that would end in a remote and little-known town named Duluth. Detractors thought it a colossal waste of money. Howell thought it humorous to stir the pot by naming the Georgia town Duluth, as well. It is a story that is lost to us today, but the name stuck, and Duluth prospered thanks to the railroad's boost to its economy.

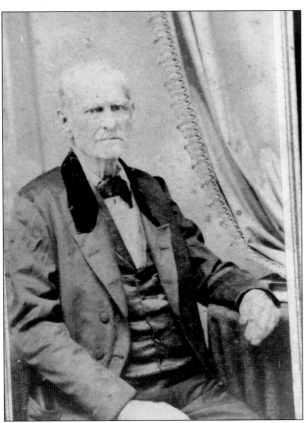

First Settler Evan Howell. The founder of Howell's Cross Roads, later to be known as Duluth, was Evan Howell, a successful farmer and merchant. Howell loved music and dancing and often invited neighbors to his plantation for parties. (Courtesy of GHS.)

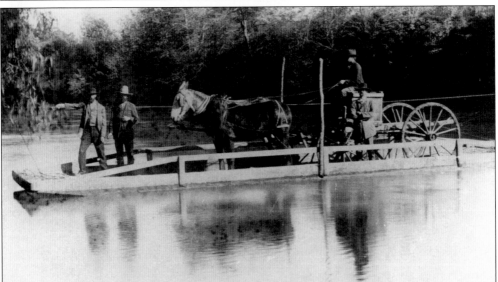

Ferry Crossing the Chattahoochee River. In this c. 1897 photograph, a ferry driver takes passengers across the river. This form of transportation was the only way to cross between Gwinnett and Fulton Counties for many years. A cable connected both sides of the river, and the ferry was pulled from one side to the other. Ferry owner Evan Howell charged a toll of 25¢ for each wagon and 6 1/4¢ for each man and horse. (Courtesy of GHS.)

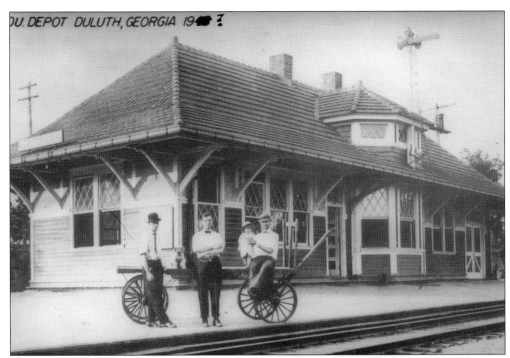

DU. DEPOT DULUTH, GEORGIA 19●● ?

WITH THE RAILROAD CAME NEW PROSPERITY AND GROWTH. Duluth's depot was dedicated in 1871, when the railroad was opened. Some residents had never seen a train before and were amazed when it came roaring down the track. The depot soon became a favorite meeting place. (Courtesy of Kathryn Parsons Willis.)

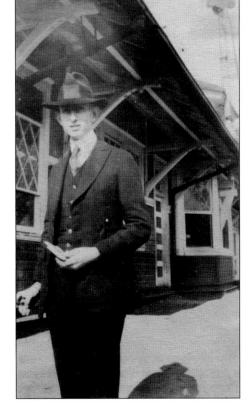

AT THE PASSENGER DEPOT. Hollis Phillips waits at the passenger depot. The rail line featured a passenger train known as the Belle that made it possible for people in Duluth to work in Atlanta. The Belle came through town every day at 8:00 a.m. and returned its Duluth passengers each afternoon. Meeting the Belle was a favorite pastime. (Courtesy of Jeanne Hall.)

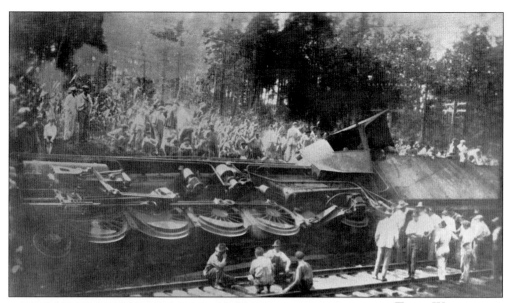

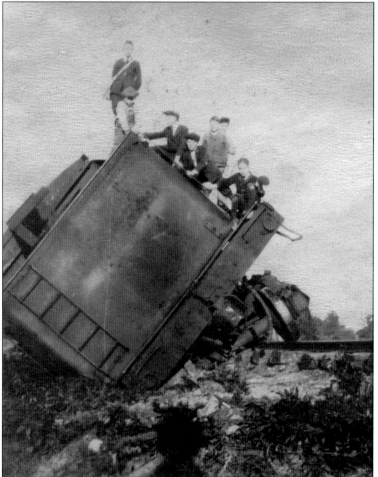

TRAIN WRECK.
A crowd gathers
around a train wreck
near Strickland
Springs in 1936.
(GWN 118.)

BOYS AT PLAY. Boys
climb on top of an
overturned railroad
car following
a train wreck,
perhaps the same
wreck as pictured
above. (Courtesy
of Jeanne Hall.)

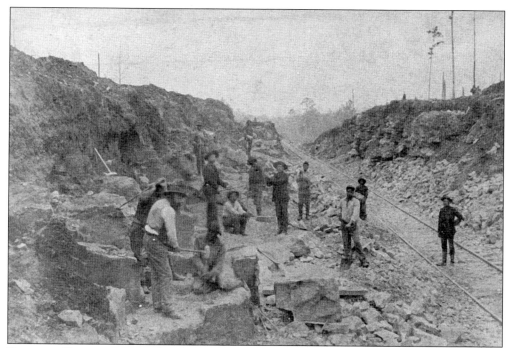

RAILROAD EXPANSION. A railroad crew breaks up rock with sledgehammers and chisels. Their foreman, Mr. Corley, stands on the railroad track and supervises. The photograph may date to 1892, when the railroad bed was expanded. (Courtesy of Kathryn Parsons Willis.)

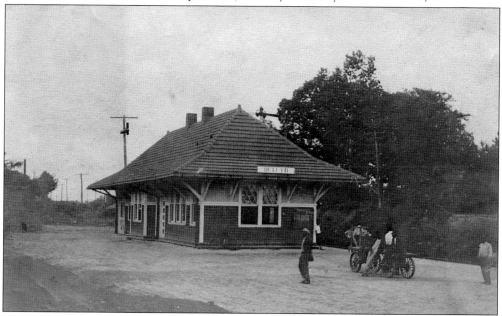

WAITING FOR THE TRAIN. The US mail also went by train. Mail sacks were hung from a hook on the east and west sides of the track, and the train would snag the sacks as it went by. Old-time residents also tell of waiting for the train engineers to throw candy out the window. This picture was made in 1908 and shows Shoat Strickland standing on the platform. (Courtesy of Kathryn Parsons Willis.)

COMMUNITY IDENTITY. Duluth's passenger train depot was typical of those designed during the height of rail travel in the late 19th and early 20th centuries. It was a one-story frame building with exterior weatherboard and tongue-and-groove siding. The roof was red clay tile. Depots in small towns were often single-story structures with broad overhanging eaves to protect travelers from the elements. A depot served as the focal point for commuters, travelers, and freight and provided community identity. (Courtesy of Jeanne Hall.)

Two

KING COTTON
AND DEMON RUM

With the coming of the railroad, Duluth saw an expansion of general stores, cotton gins, warehouses, and other commercial enterprises on both sides of Peachtree Road. Some of the first businessmen in Duluth included Capt. Bob Rogers and W.E. Jones, partners in a steam-powered cotton gin. Others included J.L. Moore, J.W. Knox, D.E. Bennett, W.E. Rutledge, and Frank Summerour. Lowe, Pittard & Company was one of the general stores in town that did a booming business when farmers finished their work on Saturday.

Unfortunately, during the 1920s, Duluth cotton farmers, like their compatriots across the South, suffered the devastating effects of the boll weevil infestation. With disease and insects wreaking havoc, Duluth felt the results financially. By 1921, the local economy had slumped. Some enterprising folks soon made up the difference by making and distributing moonshine liquor. As illegal liquor sales increased, drunken brawls and knife fights broke out on Saturday nights. With the town deteriorating, local wife and mother Alice Strickland stepped up to "clean up Duluth and rid it of demon rum." Strickland ran for mayor in 1922 and won, becoming Georgia's first female elected mayor at the age of 62.

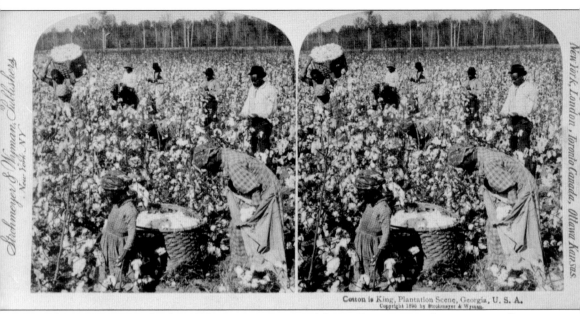

Cotton is King, Plantation Scene, Georgia, U. S. A.
Copyright 1896 by Strohmeyer & Wyman.

COTTON IS KING. In this 1895 stereoscopic view, African Americans pick cotton in a Georgia field. The caption on the image reads, "Cotton is King, Plantation Scene, Georgia, U.S.A." (GEO 147-91.)

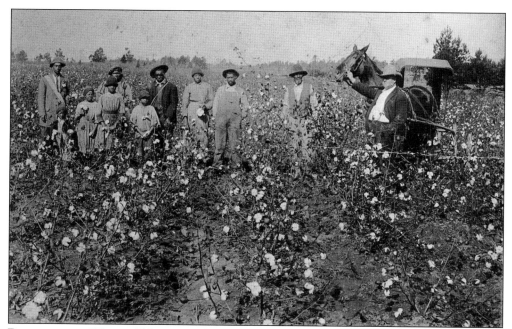

BACKBREAKING WORK. Old-time residents of Duluth say that at one time it was possible to go 200 feet outside the city limits and see cotton growing in all directions. Picking cotton was backbreaking work. In this photograph, African American workers and their overseer pause from work in a cotton field in Gwinnett County in 1912. (GWN 345.)

COTTON BALES ON MAIN STREET. Cotton was a major cash crop for Duluth farmers. During cotton season, when the crop was picked and baled, thousands of cotton bales lined Main Street on both sides. Children played tag on the bales, running along the tops for the entire length of Main Street. This first child to fall off was "out." School was turned out, sometimes for weeks, so that cotton could be brought in. At ginning time, everybody would be on street visiting. (Courtesy of Kathryn Parsons Willis.)

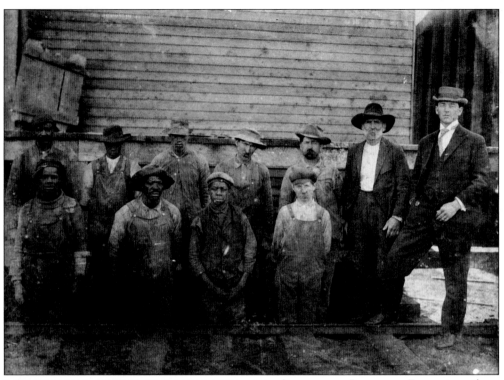

COTTONSEED INDUSTRY. Extracting oil from cotton seeds was an additional industry that grew around cotton agriculture. In this photograph, workers gather in front of a cottonseed oil mill in Gwinnett County in 1907. (GWN 349.)

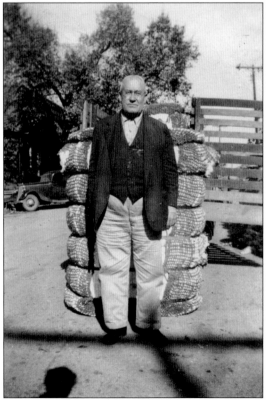

MONEY FOR THE CHURCH. In Duluth in the 1940s, John Summerour poses with a cotton bale he bought from Frances Corley, who grew cotton at her home in Duluth as a fundraiser for the Methodist church. (Courtesy of Kathryn Parsons Willis.)

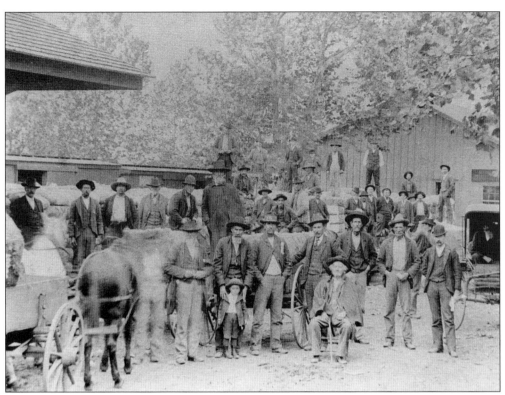

READY FOR LOADING. In a photograph taken in the 1890s, cotton farmers pose with baled cotton. The Duluth depot is on the left. Findley's Cotton Warehouse is on the right. The cotton was loaded on boxcars (visible behind the men) and shipped to textile mills. Cotton was a lucrative crop, and for the first time, Duluth farmers could ship cotton bales on a large scale. The shipping of cotton was much cheaper by rail. (Courtesy of Kathryn Parsons Willis.)

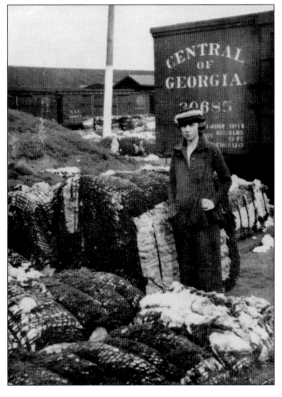

COTTON EVERYWHERE. This 1920 photograph taken at an unidentified location in Georgia shows cotton bales ready for loading onto the Central of Georgia Railroad. Eventually the price of cotton fell in Georgia. By the mid-1920s, the boll weevil had ravaged many cotton fields and robbed small farmers of a living. (GEO 148-92.)

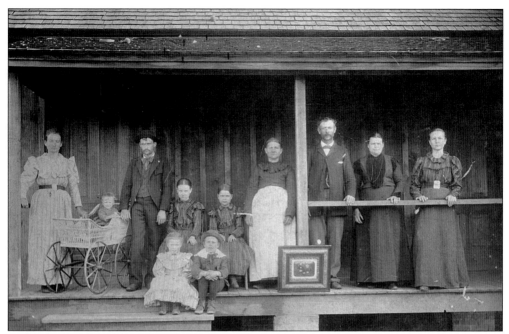

A Rough Row to Hoe. After the Civil War, large landholdings were divided into small farms. While some families owned their land, approximately two-thirds of the farmers in the state were sharecroppers prior to the Great Depression. Sharecropping, say Duluth residents who are old enough to remember growing up in sharecropper families, was "a rough row to hoe." Dependence on cash crops, such as cotton, placed pressure on farmers to plant every available acre in the crop, which depleted the soil. In this photograph dated to 1900, an unidentified family gathers on the porch of their home in Gwinnett County. (GWN 87.)

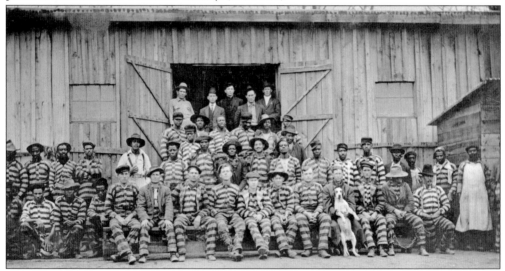

Men in Stripes. As the population of Gwinnett County increased and the effects of the economic downturn took hold, lawlessness increased. Here, convicts in Gwinnett County pose outside the jail in 1920. The men in suits behind the convicts were likely sheriff's deputies or officers of the jail. Some prisoners appear to be in leg irons, while one has taken a liking to a dog, perhaps the jail mascot. (GWN 159.)

CALABOOSE. While prisoners went to the Gwinnett County Jail to do hard time, a drunk and disorderly man on a Saturday night in Duluth might land in the Calaboose and face a fine of $5 or $6. When the Calaboose got too full on Saturday nights, police used empty boxcars to hold the overflow. The 17-by-17-foot building is made of solid concrete, as is the ceiling, and the walls are 14 inches thick. There are four bunks and a pot-bellied stove for heating. The Calaboose, built in 1909 for $500, still stands at the edge of the old Duluth Church Cemetery. (Courtesy of CoD.)

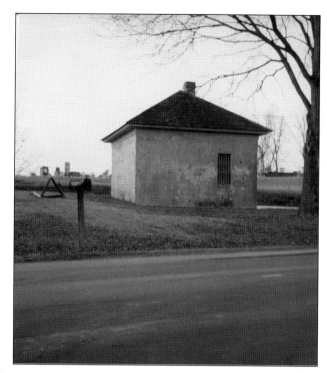

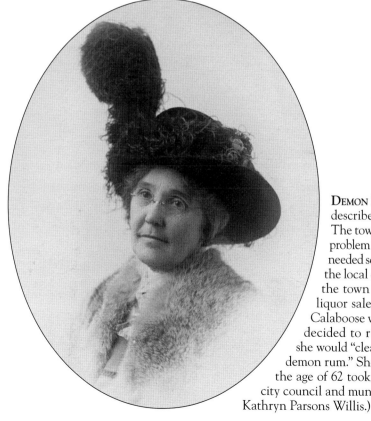

DEMON RUM. Alice Strickland was described as a stern but fair leader. The town of Duluth, she felt, had a problem with "drunken brawls" and needed some housekeeping. By 1921, the local economy had slumped and the town was deteriorating. Illegal liquor sales were rampant, and the Calaboose was often full. In 1922, she decided to run for mayor, promising she would "clean up Duluth and rid it of demon rum." She won the election and at the age of 62 took office. She presided over city council and municipal court. (Courtesy of Kathryn Parsons Willis.)

21

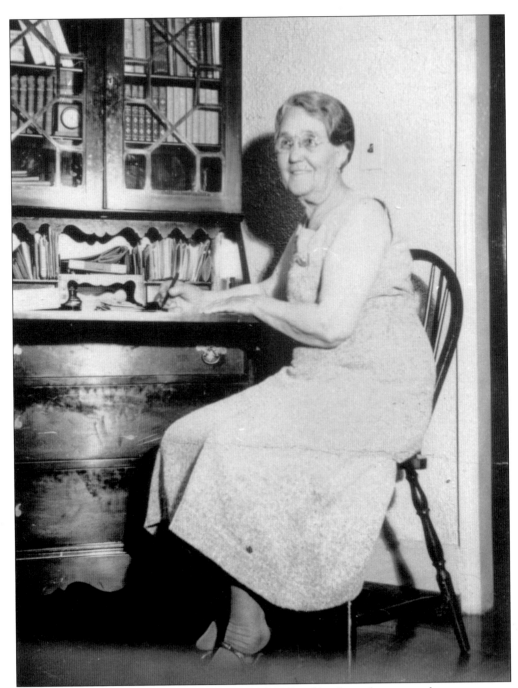

ALICE STRICKLAND AT HER WRITING DESK. Alice Strickland ran for a second term as mayor but was defeated. Her husband, Henry, was a Duluth attorney and businessman. They had seven children together. The Strickland family was one of the founding families of Duluth. Alice Strickland lived in a large two-story home that was built in 1898 and now houses the Duluth Historical Society. She lived there until her death in 1947 at the age of 88. For a time, Strickland opened the second floor of the home as a medical clinic. It included a prenatal clinic for women. (Courtesy of Kathryn Parsons Willis.)

Three

THE BUSTLE OF MAIN STREET AND BEYOND

In the early 1900s, Duluth bustled with business, especially on Saturday afternoons, when everyone stopped work and went downtown to shop and visit with friends. The Bank of Duluth, the city's first, opened in 1904 on the corner of North Peachtree Road (Main Street) and West Lawrenceville Street. A second bank, the Farmers and Merchant Bank, opened in 1911. None of the streets were paved, and all transportation, aside from the train, took the form of horse and buggy or mule and wagon. At one time, Duluth was a big mule market. Mules were shipped in by rail from Tennessee and Missouri. By the early 20th century, Duluth could boast of two livery stables, icehouses, blacksmith shops, cotton gins, corn and feed mills, and cotton warehouses.

The city weathered the Great Depression and the boll weevil, and by the 1940s, there were three cotton gins, dry goods stores, cotton warehouses, freight and passenger depots, three grocery stores, a funeral home, and service stations. When farmers and their families came to town, they traded goods for sugar and coffee. If they had money, they paid cash. If they didn't have the cash, a storekeeper would give them a chit, meaning they could pay their bill at the end of cotton season when they sold their crop. If they had a bad year and didn't make any money, often a storekeeper would hold them over to the next year and hope that the crop was better.

Parsons, a popular shopping destination for over 60 years, opened in 1925 in downtown Duluth. The original owners, Calvin and Kate Parsons, stocked their shelves with dry goods, groceries, hardware, feed, fabrics, and building materials, all items that rural folks would need. They also kept a chicken coop in back, because farmers would bring chickens and trade them for merchandise. Eventually, they opened a wholesale warehouse that supplied 11 stores in the county. Their three daughters, Ann, Kathryn, and Margaret, and the daughters' husbands also helped as the original dry goods store on Main Street grew into other Parsons ventures.

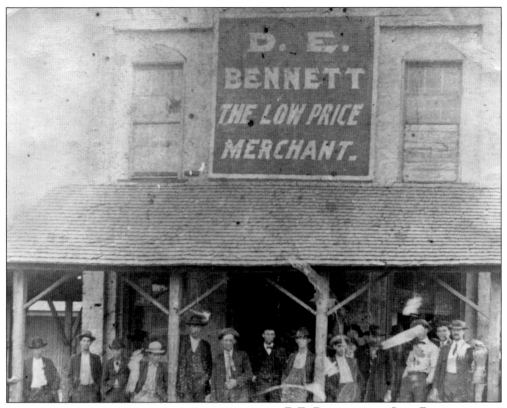

D.E. BENNETT, THE LOW PRICE MERCHANT. Men stand in front of Drew Bennett's general merchandise store in this photograph from the late 1800s. This is one of the oldest extant buildings in Duluth. (Courtesy of GHS.)

D.E. BENNETT. Merchant Drew Bennett is pictured in the late 1800s. (Courtesy of Jeanne Hall.)

BENNETT EMPLOYEE. Bennett had employees to help in the store, including this young man. (Courtesy of Jeanne Hall.)

D.E. BENNETT. Drew Bennett is pictured as he appeared later in life. (Courtesy of Jeanne Hall.)

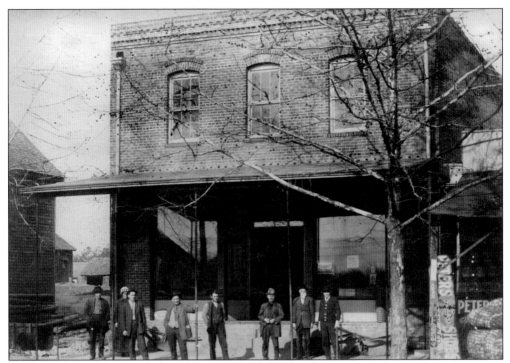

DOWNTOWN STORE. Men pose in front of a downtown Duluth building in 1900. The building faced Peachtree Road (Main Street). While built as a store, the structure has also been a warehouse and a bowling alley. It also housed the Masonic lodge upstairs. (GWN 262.)

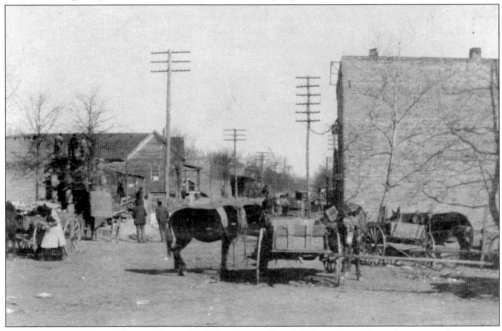

SOUTH PEACHTREE. The south end of Peachtree Road (Main Street) is shown in downtown Duluth in the early 1900s. There were no paved roads in town at the time. (Courtesy of Kathryn Parsons Willis.)

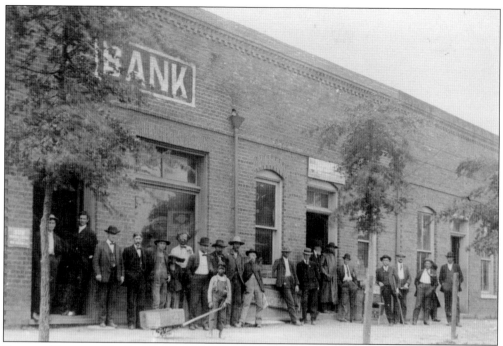

BANK OF DULUTH. The Bank of Duluth attracts a crowd in this photograph from the early 1900s. Both this bank and the Farmers and Merchants Bank were forced to close during the Depression, although the Bank of Duluth reopened in 1945 in the same building. (Courtesy of GHS.)

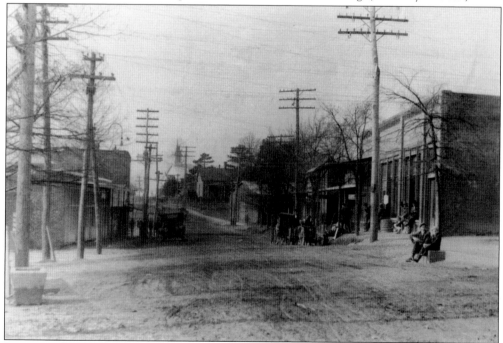

SOUTH PEACHTREE. South Peachtree Road eventually became known as Main Street. In this photograph from 1910, only a few residents are about. The Methodist church is in the background. The Calaboose would have been to the left of the church. (Courtesy of GHS.)

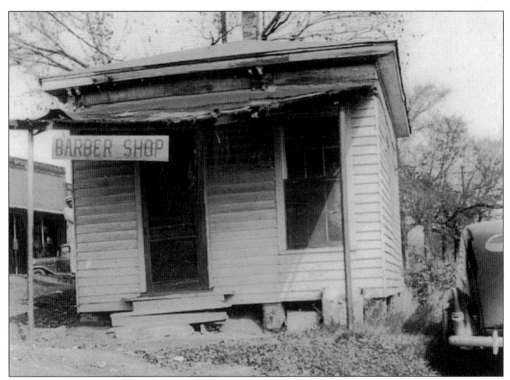

ONE CUT FOR ALL. Will Dodson's barbershop, pictured around 1940, was home to the 25¢ haircut. Dodson wore red suspenders and never charged more than 25¢ a customer. Old-time residents who remember getting a haircut there say Dodson had only one style. One could request a different style, but "you still came out looking like you had a bowl on your head," says one former customer. (Courtesy of Kathryn Parsons Willis.)

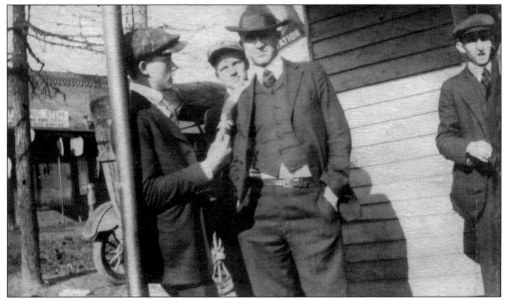

WAITING FOR A HAIRCUT. Young men wait for a haircut outside Dodson's barbershop. (Courtesy of Jeanne Hall.)

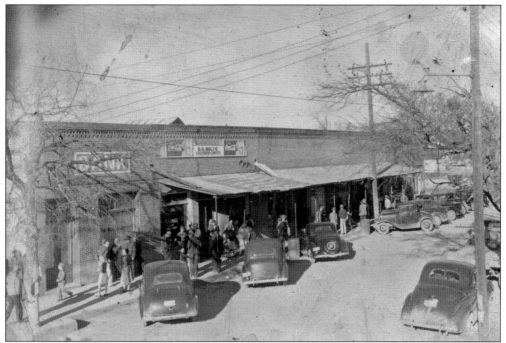

PARSONS—SOMETHING FOR EVERYONE. Downtown Duluth buildings north of the Main Street–West Lawrenceville Street intersection are shown in this image from the 1930s. The bank on the left opened in 1904. Parsons general store opened in the building in 1925. At the time of the photograph, the center portion of the building was O.H. Boles Café. Kathryn Parsons Willis remembers that her first job at her parents' general store was scraping chewing gum off the floors. Kathryn and her two sisters, Ann and Margaret, also swept the floors and retrieved Coca-Cola bottles for return to the bottler. Kathryn and Ann remain active in family gift stores in Cumming, Duluth, and Alpharetta, Georgia. (Courtesy of Kathryn Parsons Willis.)

MAIN STREET. Downtown Duluth in the 1950s is seen in this photograph, which was shot facing southwest. Buildings are to the south of the Main Street and Lawrenceville Road intersection. (Courtesy of Kathryn Parsons Willis.)

MAIN STREET, 1950s. Downtown Duluth was photographed facing southwest in the 1950s. The photograph shows the original intersection known as Howell's Cross Roads. (Courtesy of Kathryn Parsons Willis.)

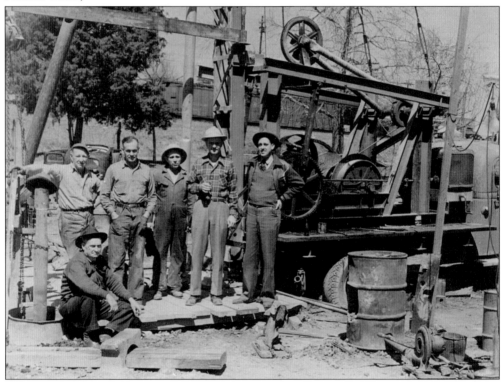

FIRST CITY WELL. Workers pause during construction of the first city well in Duluth in 1948. This site turned out to be a dry hole. Before the drilling of a well, a hand-dug well existed across from the Bank of Duluth. It was a popular meeting place for Duluth residents, who all drank from the same dipper. While the mechanically drilled well was a welcome addition to utility services, the city was still in danger of fires because of the lack of city water piped along the streets. (Courtesy of Kathryn Parsons Willis.)

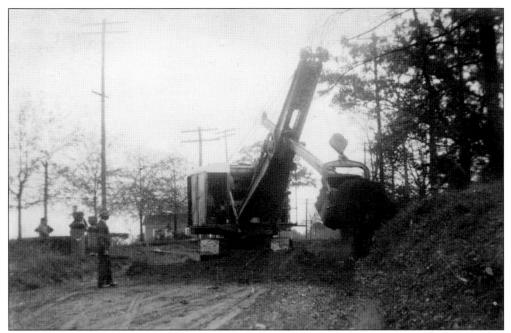

BUILDING BUFORD HIGHWAY. In this image from the 1930s, heavy machinery is used to grade what will become Buford Highway, the second paved road through Duluth. Main Street was paved in 1929. (Courtesy of CoD.)

A WASTE OF MONEY. In this image, Buford Highway is under construction. The concrete highway was technologically up to date, with curbing and drainage aprons. Old-timers were sure that it was a waste of money and would never be busy. The highway opened in 1936. (Courtesy of CoD.)

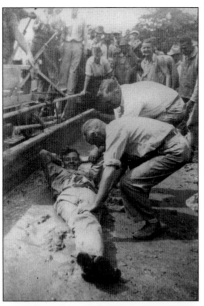

WET CEMENT. Workers celebrate the pouring of the last section of Buford Highway (US 23) near Duluth in 1936 by rolling a Duluth resident in wet cement. The highway was the first paved thoroughfare in the northern and western areas of Gwinnett County. It stretched from Gainesville in the north to Atlanta in the south. (Courtesy of Kathryn Parsons Willis.)

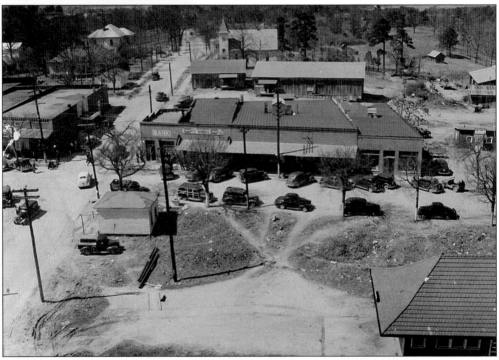

BIRD'S-EYE VIEW. Panoramic views of Duluth were taken in the 1940s by Jay Summerour, who climbed the water tank near the railroad depot to get the shots. This photograph shows a western-facing view of the intersection of Peachtree and Lawrenceville Roads in downtown Duluth. The church in the background (center) is the Duluth Baptist Church, which burned in 1947 and was replaced with a stone structure. The church eventually moved to a new structure on SR 120. The roof at the bottom right is the train depot. The bank on the left and the other stores to the right became Parsons stores, which were popular sites for shopping until 1987. (Courtesy of Kathryn Parsons Willis.)

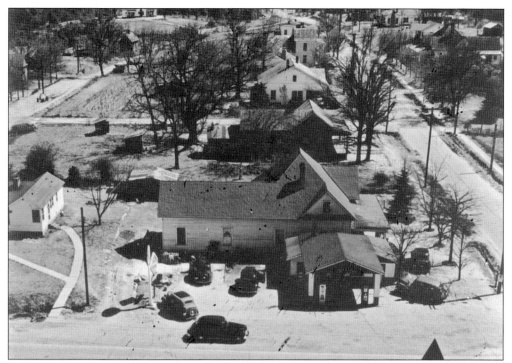

FROM THE WATER TANK. Buford Highway is in the foreground, and Lawrenceville Road is on the right. The service station near the bottom of the photograph was later Ted's Fruit Stand, a popular business in the 1980s and 1990s. (Courtesy of Kathryn Parsons Willis.)

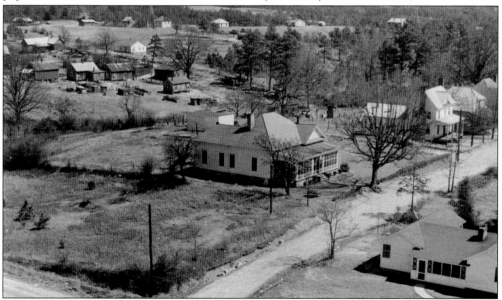

BIRD'S-EYE VIEW. This view was taken from the top of the water tank looking northeast. Buford Highway is in the foreground intersecting with Howell Street. The Hill, Duluth's black neighborhood, is in the background. The Hill has always been a tight-knit community dating back at least 120 years. Originally, many of the residents were descendants of slaves who worked the plantations along the Chattahoochee River. (Courtesy of Kathryn Parsons Willis.)

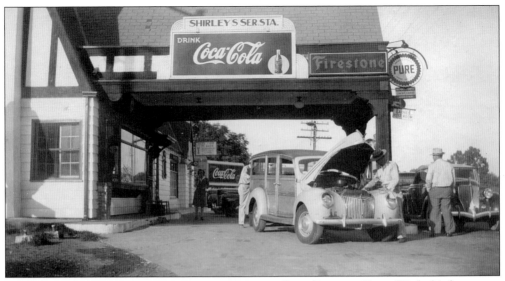

FULL SERVICE. One of Duluth's first service stations was owned and operated by Walt Shirley. (Courtesy of Kathryn Parsons Willis.)

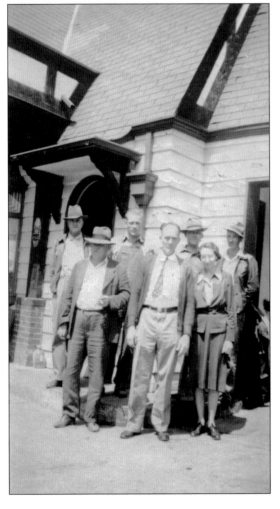

SHIRLEY'S SERVICE STATION. Standing in front of Walt Shirley's service station in the 1940s are (from left to right) George Bennett, Frank Mattison, Buck Askew, Jim Rainey, LeRoy Echols, Nancy Little, and Hugh Johnson. (Courtesy of Kathryn Parsons Willis.)

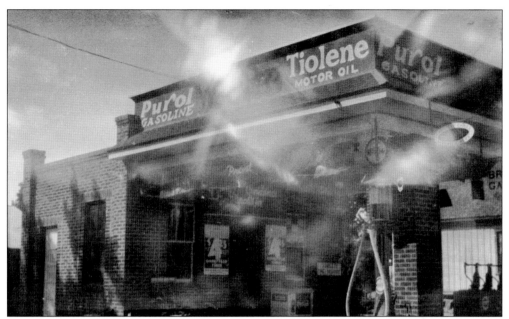

TIRES FOR $4.25 APIECE. In 1933, Allen Brown opened a service station on Peachtree Road, just south of the main block of stores in Duluth. He sold Purol Gasoline, Tiolene Motor Oil, and tires for $4.25 each. (Courtesy of Michael Brown.)

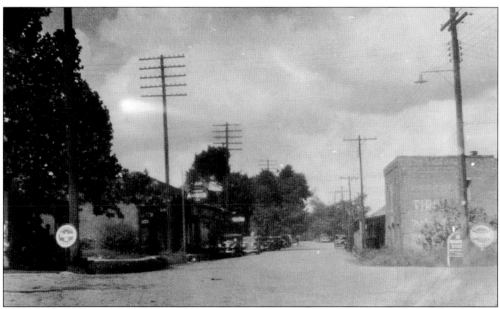

LOOKING SOUTH. From Brown's Service Station looking south on Peachtree Road, commercial brick buildings and telephone poles dwindle to a rural landscape in this image from 1933. (Courtesy of Michael Brown.)

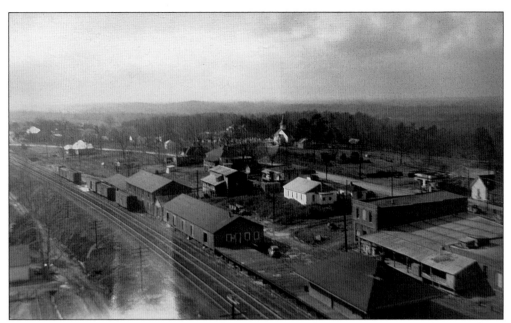

FROM THE WATER TANK. The water tank's height made it a tempting spot for photographers. The images on this page were taken by Eugene Brown, Allen Brown's son, in January 1945. The photograph above is of Duluth, looking southwest. The freight depot is in the foreground, followed by cotton warehouses and boxcars on the railroad tracks. The Duluth Methodist Church can be seen in the background. (Courtesy of Michael Brown.)

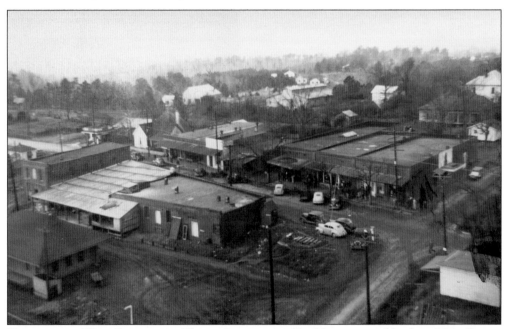

TOWARDS THE WEST-SOUTHWEST. The city's commercial buildings are visible along Main Street. Brown's Service Station is at the far left. The white building in the center on the east side of Main Street is now the Red Clay Theater. The building next to it has been demolished. A new restaurant is planned in its place. (Courtesy of Michael Brown.)

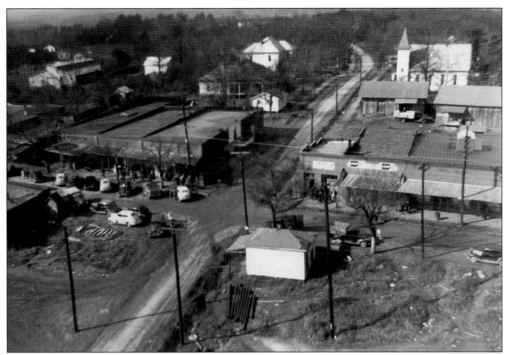

LOOKING WEST. Duluth was photographed looking west at the intersection of Main Street and West Lawrenceville Road. Parsons stores and warehouses are on the right. Behind them is the Duluth Baptist Church. The little white building in the foreground is Dodson's barbershop. (Courtesy of Michael Brown.)

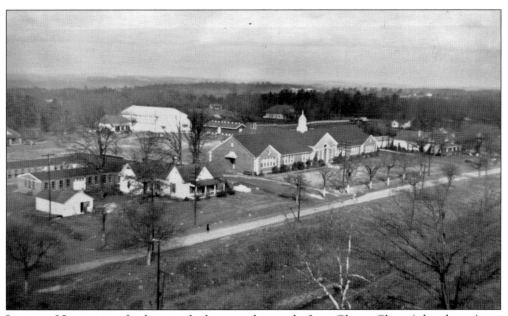

LOOKING NORTHWEST. In this view looking northwest, the Joan Glancy Clinic (white house) can be seen next to Duluth School, built around 1936 (on the right). (Courtesy of Michael Brown.)

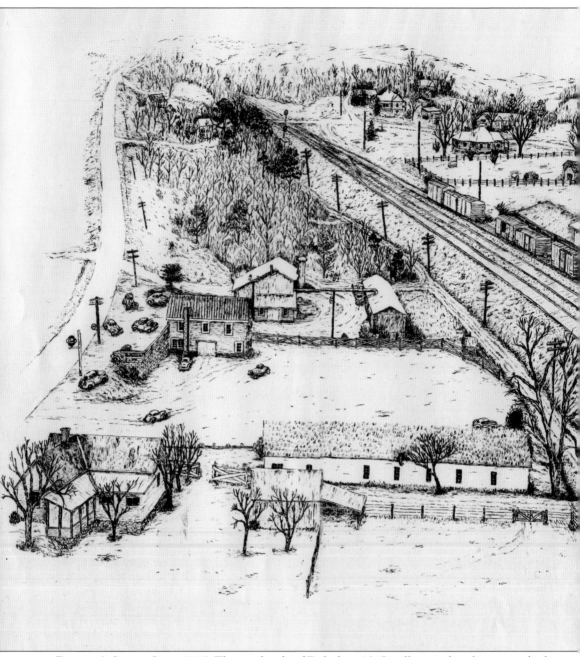

DULUTH'S SOUTH SIDE, 1945. The south side of Duluth in 1945 is illustrated in this pen and ink

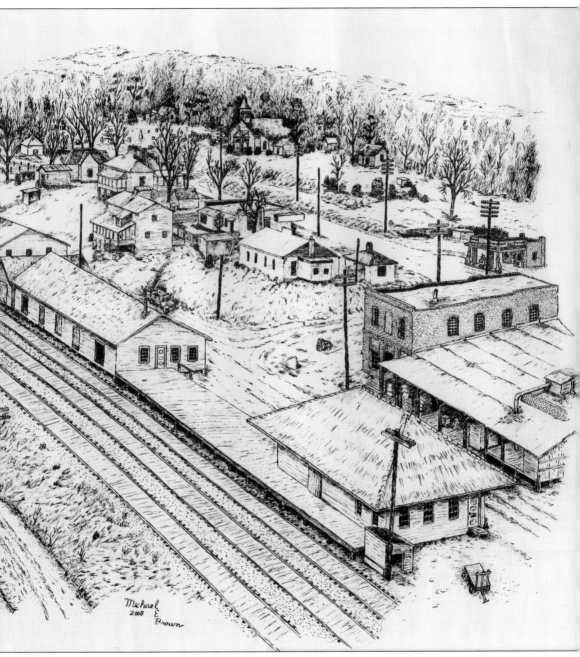

drawing by Michael Brown.

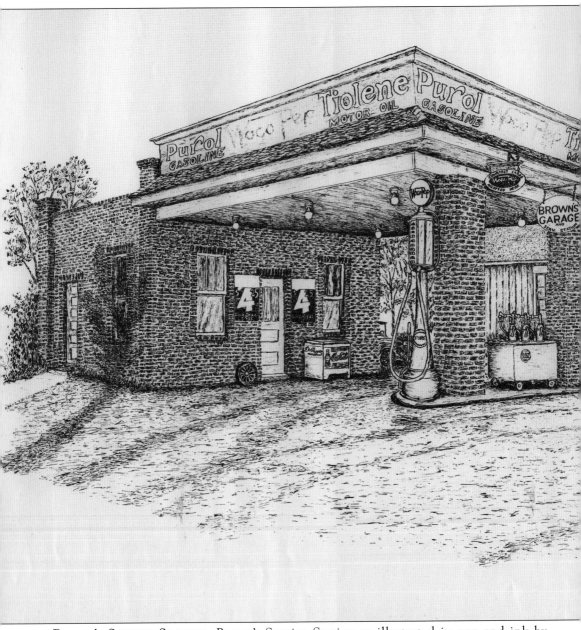

BROWN'S SERVICE STATION. Brown's Service Station as illustrated in pen and ink by

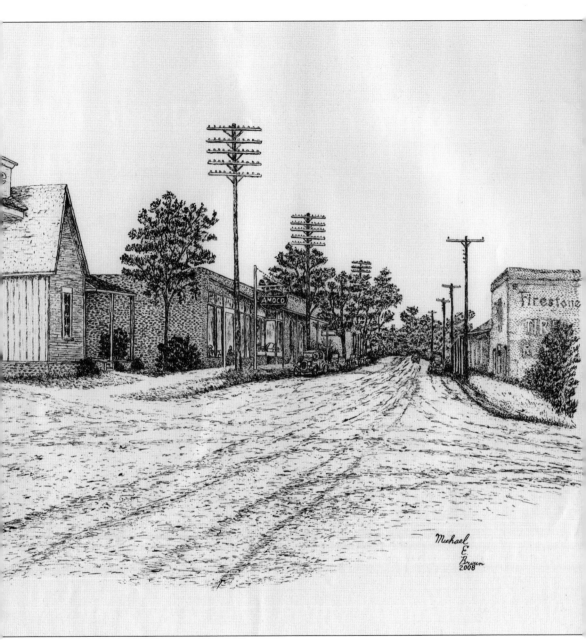

Michael Brown.

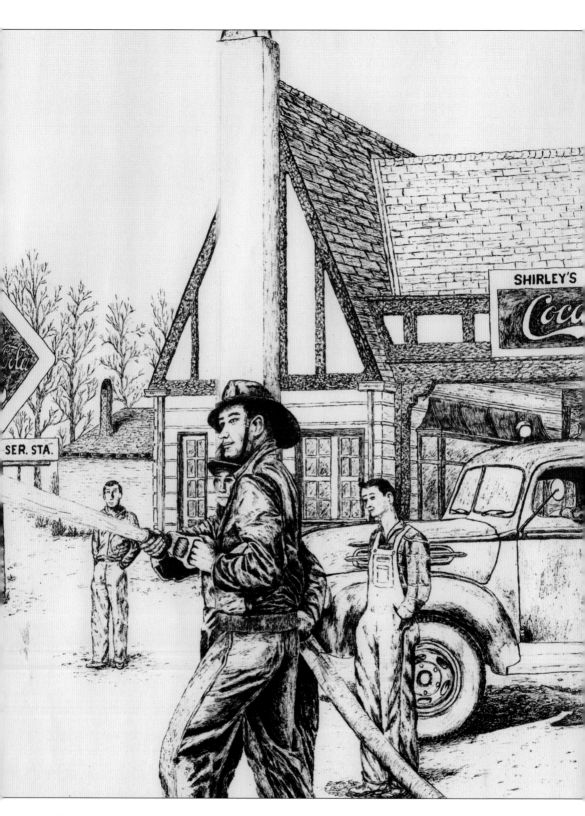

SHIRLEY'S SERVICE STATION. Fire department training at Shirley's Service Station is illustrated in pen and ink by Michael Brown.

43

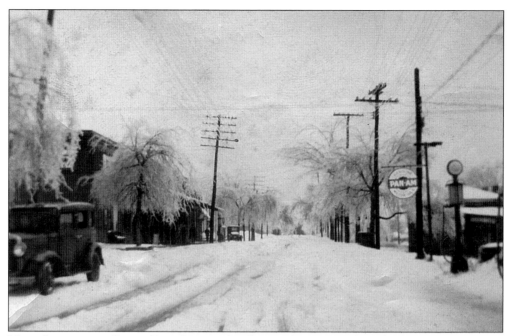

MAIN STREET ON A SNOWY DAY. Snow makes for treacherous travel on the downtown streets of Duluth following a 1934 snowstorm. This was the coldest spell that old-timers remember. Even the Chattahoochee froze over that year, and some bragged that they walked across it. (Courtesy of Kathryn Parsons Willis.)

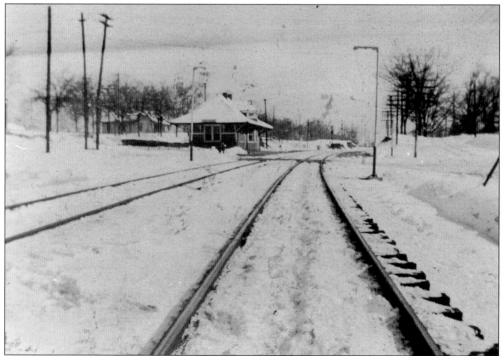

WINTER ON THE RAILROAD. The depot looks like a lonely place in this photograph of a snowy winter scene from the 1930s. (Courtesy of Kathryn Parsons Willis.)

GEORGE BENNETT'S STORE. George Bennett, son of downtown merchant Drew Bennett, followed in his father's footsteps by opening a store on Main Street in the 1950s. Bennett sold furniture and would let people pay for their purchase over time. His customers would come in on Saturday and make their weekly payment. (Courtesy of Jeanne Hall.)

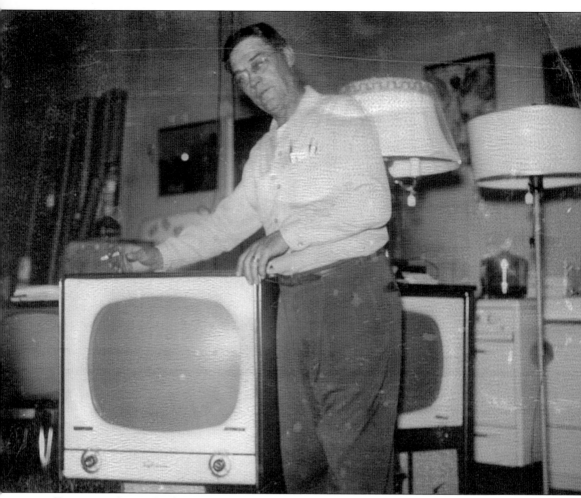

FURNITURE STORE. In this image, George Bennett displays the latest in 1950s television sets in his store. Bennett provided customers a special incentive to purchase living room furniture. He offered them free lamps, a radio, or a picture with each living room suite. (Courtesy Jeanne Hall.)

Four

ETERNAL SPRINGTIME

Once there was a little boy, age six, who died at Christmastime for wont of proper medical care. And once there was a little girl, age four, who died of pneumonia despite the best care of two specialists. The boy was a dairy farmer's son from Duluth, Georgia, and the girl was the beloved daughter of well-to-do parents in Detroit, Michigan. These children never met and never knew each other. But their deaths motivated an entire community and served as inspiration for the nation.

The story starts in 1941 on the 400-acre Irvindale Dairy Farm and country retreat of Atlanta businessman Richard Hull near Duluth. One of Hull's dairymen was Henry Burnett, father to six children. One of the children, Olin, fell ill. He might have lived if there had been a hospital in the county, but with no medical facility available, the boy died on a Sunday after several days of suffering. Hull and the grief-stricken Burnetts came into town and asked Calvin and Kate Parsons to slip out of church and open up their store so the family could get clothes for their little boy's funeral. Hull, deeply disturbed by the death of Olin, watched Mrs. Parsons gather burial clothing for the boy and asked, "Why can't we have a clinic where children can be examined and medical aid provided?" Kate Parsons agreed, and she and Hull began to rally the townspeople. A group of people met at the school house to discuss how they might open a clinic. They collected $80 with pledges of $50 more. There was very little money to spare in Duluth those days. They couldn't afford much, but decided they could get a little hospital started in an old frame house at the edge of the school yard.

Meanwhile, Richard Hull's wife was so touched with the response that she decided to share the story with her father, Gen. Alfred R. Glancy, vice president of General Motors in Detroit and the developer of the Pontiac automobile. Also impressed, he sent a check in memory of his daughter Joan, who had died 17 years before at the age of four from pneumonia. Little Joan Glancy, affectionately known by her doting parents as Jody, was "strong, healthy, cheerful and loving," according to her father.

Glancy's check and the pledges meant that a 24-hour duty nurse could staff the hospital, with Dr. Jack Cain of Norcross providing additional medical care three days a week. Heard Summerour, Duluth's postmaster, wrote Glancy to thank him for the donation and suggested that the new clinic be named in honor of Joan. Glancy gave his permission and sent a $500 check and pledge of $250 to be made "each year, on the 4th day of April, which was the birthday of our Joan."

An old frame house was renovated, and in 1941, Joan Glancy Clinic opened as a multiroom facility with patient beds and a combination operating room, delivery room, and clinic that both black and white were free to use. The facility, which served the needs of 600 residents plus those from a three-county area, was an instant success. However, when Glancy traveled to Duluth to see the hospital that bore his daughter's name, he was appalled. He was used to the more modern facilities in Detroit, and the old frame house was not his idea of a proper hospital. He told the people of Duluth that if they could raise the money to buy some land and dig a well, he would pay to build a proper modern steel-and-concrete hospital. Glancy was adamant, however, about the source of the money for the land and well: "If a half dozen citizens furnish the money, I am not interested. The sacrifice must come from everyone in the town."

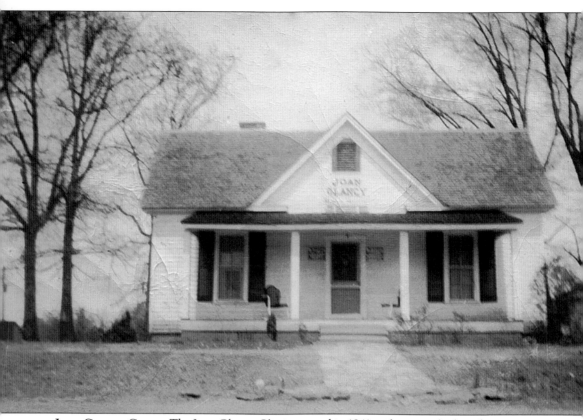

JOAN GLANCY CLINIC. The Joan Glancy Clinic opened in 1941 with patient beds and an operating room. It was an instant success. At first, it was staffed by a 24-hour duty nurse, and doctor's hours were provided three days a week by Dr. Jack Cain of Norcross. Soon the patient list grew and a full-time doctor was hired. (Courtesy of Kathryn Parsons Willis.)

BABY BOOM. The clinic offered round-the-clock treatment for sick babies and a safe place for women to go through labor and delivery. (Courtesy of Kathryn Parsons Willis.)

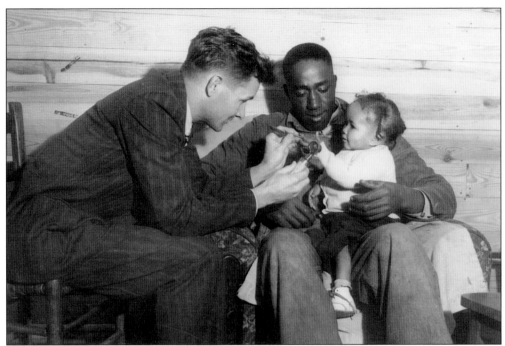

MEDICAL CARE FOR ALL. In this image, Dr. Parker examines a young patient at Joan Glancy Clinic. (Courtesy of Kathryn Parsons Willis.)

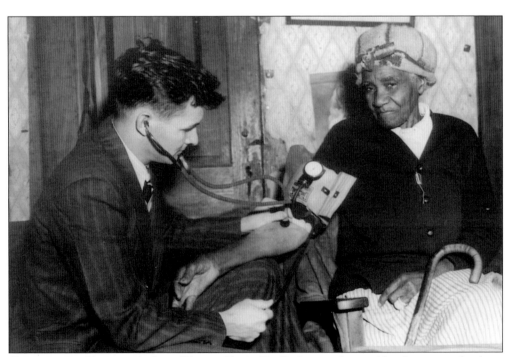

CARE FOR THE ELDERLY. At Joan Glancy Clinic, Dr. Parker conducts a blood pressure check on an elderly patient. (Courtesy of Kathryn Parsons Willis.)

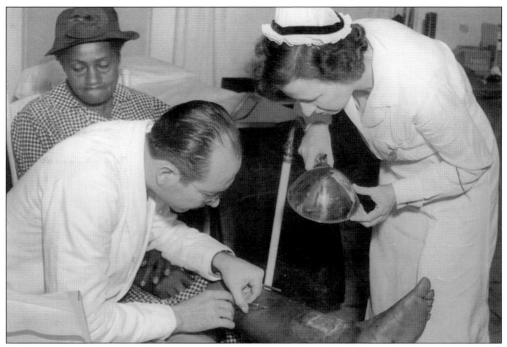

PROPER TREATMENT. While a patient grits her teeth, Dr. Jack Cain gives her an injection of anesthetic prior to cleaning the wound on her leg. (Courtesy of Kathryn Parsons Willis.)

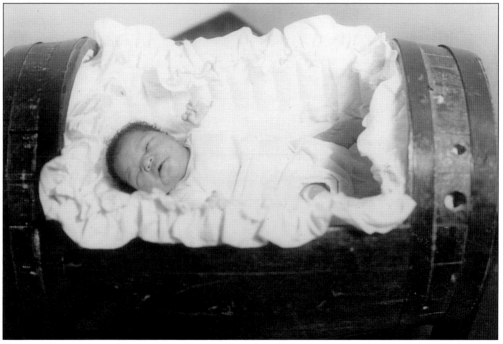

BARREL BASSINET. Almost immediately after the clinic opened, babies began to be born at Joan Glancy by mothers grateful not to have to labor alone far from medical care. The black community on the Hill created their own snug bassinet out of a barrel. (Courtesy of Kathryn Parsons Willis.)

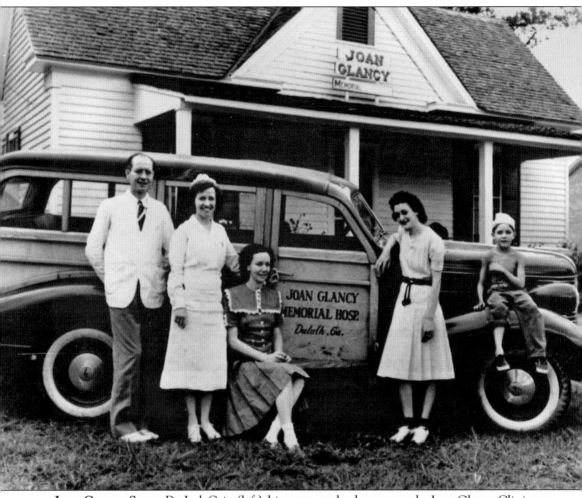

Joan Glancy Staff. Dr. Jack Cain (left), his nurse, and volunteers at the Joan Glancy Clinic are pictured with the vehicle that allowed them to bring medical care to rural areas. *Atlanta Journal-Constitution* columnist Harold Martin accompanied a traveling nurse from Joan Glancy Clinic on her rounds of patients in the community. He wrote about a cold, blustery day and dirt roads "that were washboardy, jouncing the old station wagon and making it groan in every joint." Martin describes a home visit as follows: "At the next house, bare but spotlessly clean, a blind old mother got her shot of thiamin, with its life-giving vitamin B, which most of these people, weakened by years of inadequate diet, need so desperately. Her daughter, aching with sinusitis, got a shot that would ease her, and then, bringing out her pocketbook, she counted out nickels and pennies to make up a quarter in payment. The nurse never asks for a fee, but these are a proud and honest people and they pay what they can." Pictured with Dr. Cain are Mary Findley (seated), Berma Parsons (standing at right), and Guy Ben Findley. (Courtesy of Kathryn Parsons Willis.)

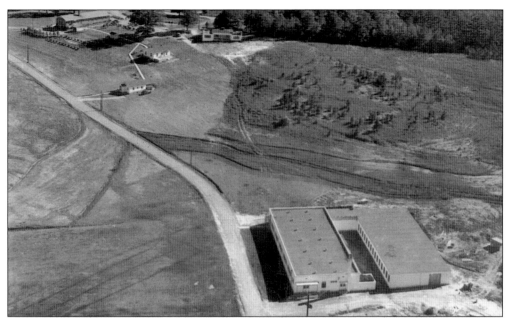

THE GKW FACTORY. Every person in town, from the poorest to the most well-to-do, contributed to the cause of buying land and drilling a well for the new hospital after Gen. A.R. Glancy promised to build the facility. They raised $4,000, bought 23 acres, drilled a well, and prepared the site. In 1944, the 26-room brick-and-steel Joan Glancy Memorial Hospital was dedicated. To keep it running, Glancy built a factory nearby with profits to be funneled into the hospital. The new hospital treated 600 patients a month, and no one was turned away for lack of payment. The factory, seen in the photograph above, was known in jest as the GKW or Goodness-Knows-What factory, because Glancy had no idea what he would manufacture there; he simply wanted to make sure that the hospital could survive financially. The factory paid workers an unheard-of 90¢ an hour in wages. (Courtesy of Kathryn Parsons Willis.)

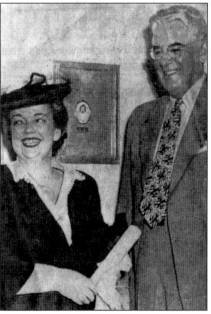

DEDICATION FOR THE HOSPITAL. Kate Parsons and Gen. A.R. Glancy are shown at the dedication of the Joan Glancy Memorial Hospital in 1944. The hospital cost $120,000 to build. By 1951, it was handling 4,000 patients a month, delivering 75 babies a month, and treating 400 dental patients a month. By 1980, the hospital was the largest in the Gwinnett County hospital system. Mrs. Parsons was chair of the Joan Glancy Board for many years. (From the *Atlanta Journal-Constitution*.)

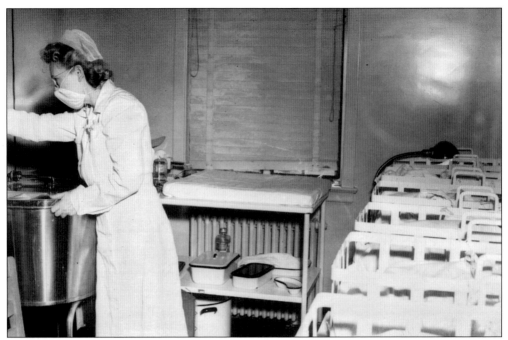

MODERN EQUIPMENT. Babies born at the new hospital were placed in bassinets and warmed with a heat lamp. (Courtesy of Kathryn Parsons Willis.)

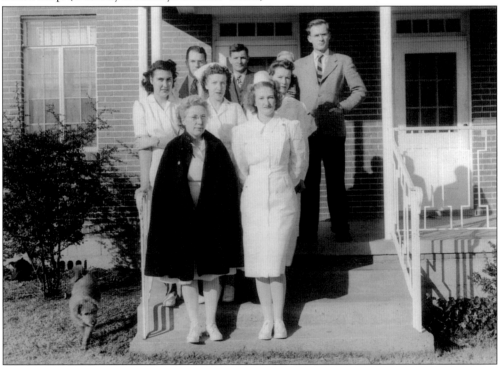

NURSES AND DOCTORS. Hospital staffers pause from their duties to gather for a photograph, probably around 1950. Nurses were expected to wear starched white uniforms and caps. (Courtesy of Kathryn Parson Willis.)

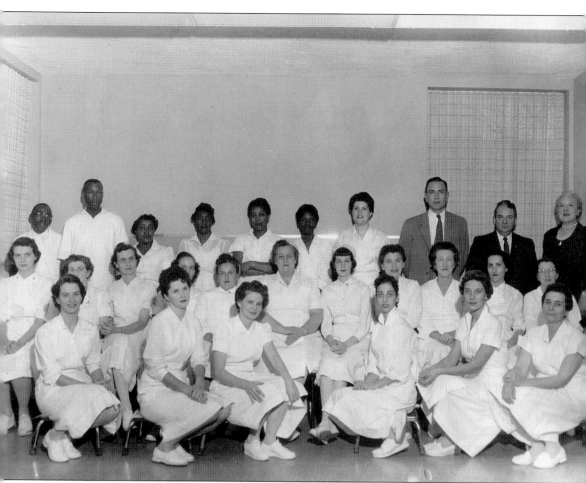

HOSPITAL STAFF. The entire hospital staff poses for a portrait in this photograph dated around the early 1950s. The three people standing to the far right in the third row are, from left to right, Dr. Miles Mason, Henry Seay (director of finances), and Loye Payne (hospital administrator). Dr. Miles "Daddy" Mason was the first full-time doctor in Duluth. He was often paid for his services in vegetables and other goods. He kept an office in the hospital where he delivered about 1,500 babies over the course of his career. His son, also Dr. Miles Mason, is currently chief of staff of the Gwinnett Medical System. He also has a practice in Duluth. (Courtesy of Kathryn Parsons Willis.)

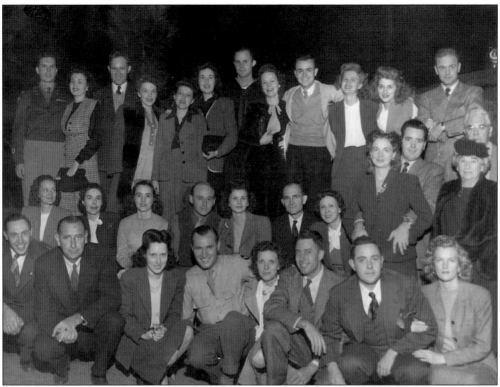

A Party for the Glancys. Duluth partygoers celebrate the new hospital with Gen. and Mrs. A.R. Glancy, the older couple on the far right in the middle rows. (Courtesy of Kathryn Parsons Willis.)

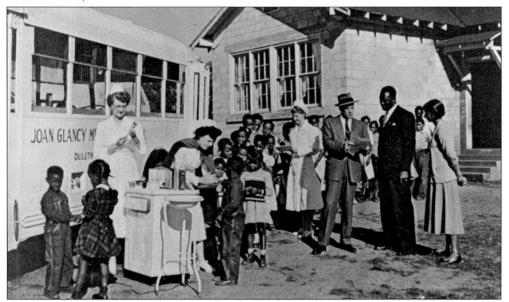

Diagnostic Van. A mobile van from the hospital served the health care needs of the county. In this photograph, nurses have taken the unit to a black school to vaccinate the children. (Courtesy of Kathryn Parsons Willis.)

A Portrait of Joan and Her Puppy. Joan Glancy died too young to know the success of the hospital named after her, but many Duluth residents who were children when the first hospital was established are employees or volunteers in the facility today. Like her mother, Kathryn Parsons Willis is a board member, having served for 21 years. (Courtesy of Kathryn Parsons Willis.)

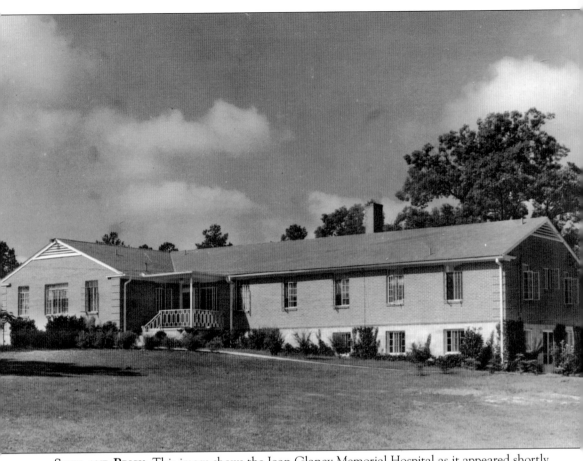

STEEL AND BRICK. This image shows the Joan Glancy Memorial Hospital as it appeared shortly after it was constructed in 1944. Today, the Joan Glancy facility serves as a rehabilitation center. On its cornerstone is a reminder of why the building is there: "To Joan, who in swift transition achieved eternal Springtime, this hospital is dedicated in the hope that through it the lives of other children may be enriched." (Courtesy of GHS.)

Five

PRAYER AND STUDY

As is typical with small Southern towns, Duluth citizens established a Baptist church and a Methodist church shortly after the community's founding. There were also black churches on the Hill: Mount Carmel Baptist Church, the oldest continually operating church in Duluth, and Friendship Baptist Church. Mount Carmel would have services on the first and third Sunday and Friendship on the second and fourth Sundays. Worship on Sunday—sometimes all day on Sunday—was an essential part of the week. The Methodist church, located at the south end of town, and the Baptist church, located in the center of town, had "preaching" services on alternate Sundays and Sunday school every Sunday morning. As one old-time resident asked, "What else was there to do on Sunday in a small town but go to church?"

For Duluth's children, the rest of the week was taken up with work at home or in the fields and schoolwork. Classes were held at first in small one-room schoolhouses scattered throughout the county. Duluth's first school, built in the 1870s, was a two-room building that was replaced by a brick schoolhouse in 1925. It was struck by lightning and burned in 1935, and it was replaced in 1936 by a brick building, which has since been replaced.

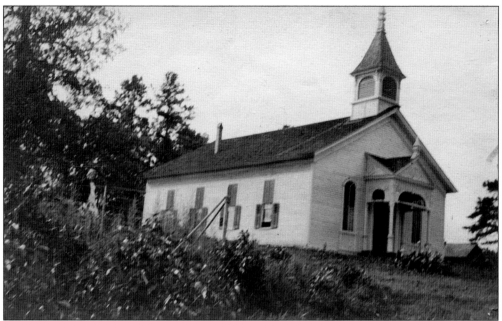

DULUTH METHODIST CHURCH. Duluth Methodist Church was organized under the pastorate of Rev. G.R. Kramer in 1871. The charter members were S.G. Howell, Agnes J. Howell, Mr. and Mrs. W.E. Jones, Dora Howell, H.W. Howell, Cynthia E. Howell, and J.J. Herrington. John Knox, mayor of Duluth from 1880 to 1885, organized the first official meeting of the church, but his buggy got stuck in mud and he could not attend. Therefore, he was not considered an official charter member. (Courtesy of Kathryn Parsons Willis.)

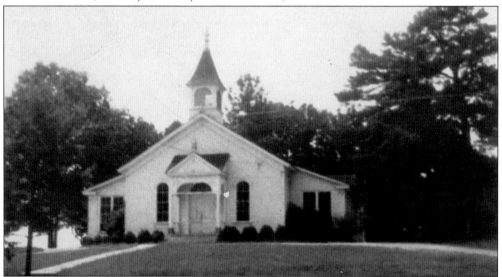

DULUTH METHODIST CHURCH. The church building was erected in 1873 at a cost of $1,000. The land was donated by Singleton Howell, son of Duluth founder Evan Howell. The church was added on to in 1921 and 1954. The cemetery was located behind the structure. A new church was eventually built on SR 120 southeast of town. The old church was moved to a new location, and a new city hall was built in its place. This photograph shows the two wings that were added in 1921. (Courtesy of CoD.)

BAPTIST CHURCH OF DULUTH. The Duluth Baptist Church was organized on February 13, 1886. A church building was erected the same year at a cost of $500 and used until 1907, when a second building was constructed at a cost of $1,200. A new church was built in the 1950s. The charter members were Julia Flowers, Henrietta Vaughan, Amanda E. Gorman, Sarah McKinney, Agnes Pittard, Lou Scoggins, Sarah Maddox, Julia A. New, J.L. Vaughan, Ansel Morgan, J.M. McKenney, E.M. Pittard, Thomas D. Gorman, Emory Flowers, and J.C. New. In 1911, Heard Summerour, also the town's postmaster, served as superintendent, and Mack Pittard served as assistant superintendent. (Courtesy of CoD.)

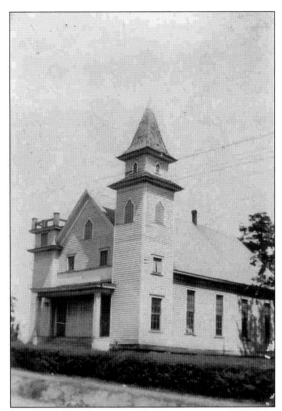

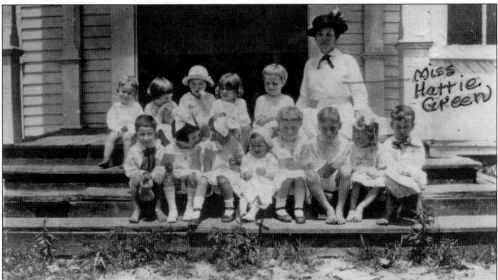

SUNDAY SCHOOL CLASS. Sunday school teacher Hattie Green stands with her class on the steps of Duluth Methodist Church. Included in the photograph are, from left to right, (first row) Henry Summerour, Clare Strickland (Findley), Virginia Boyce Wilson, Mary Cecil Summerour, Virginia Dodd, Bill Jones, Sarah Lee Payne, and Robert Summerour; (second row) Noel Summerour, three unidentified, and Katherine Dodd. Notice that although some of the children are dressed in their finest, several are barefoot. (Courtesy of Kathryn Parsons Willis.)

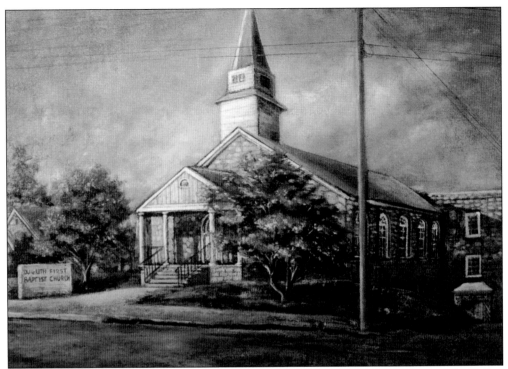

BAPTIST CHURCH OF DULUTH. When the church building was destroyed by fire in July 1947, a new church was built in 1948 of brick, rock, and Stone Mountain granite. The church has now moved to a new facility southeast of town on SR 120. The stone building served as city hall until the new town hall was built on the site of the Methodist church. (From a painting by Ann Parsons Odom.)

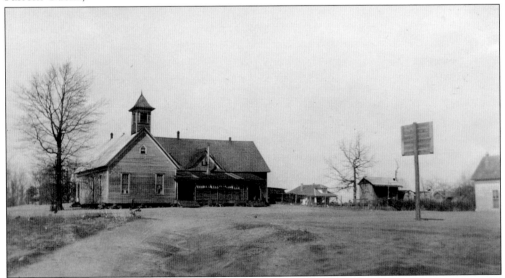

DULUTH'S FIRST SCHOOLHOUSE. Duluth's first schoolhouse was built in the 1870s on the site of the present-day middle school. Land for the school was donated by Singleton Howell, son of Duluth's founder, Evan Howell. It was a two-room schoolhouse with two teachers, one for the lower grades and one for the upper grades. (Courtesy of Kathryn Parsons Willis.)

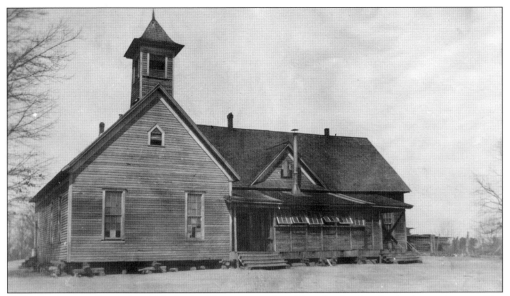

DULUTH SCHOOL DAYS. In 1925, this building was replaced by a brick school, which was destroyed by fire in 1935. Duluth School was then rebuilt on the site. (Courtesy of Kathryn Parsons Willis.)

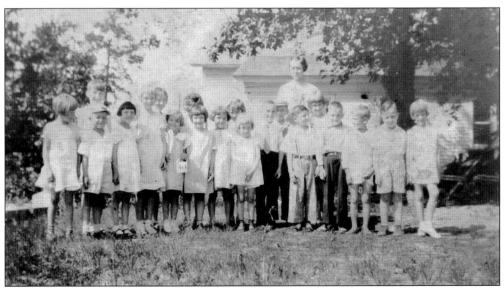

GATHERING. This group of children may have been in the same school or Sunday school class. Judging from the good dresses, the frilly socks, and the fact that no child is barefoot, this may have been a church photograph. (Courtesy of Michael Brown.)

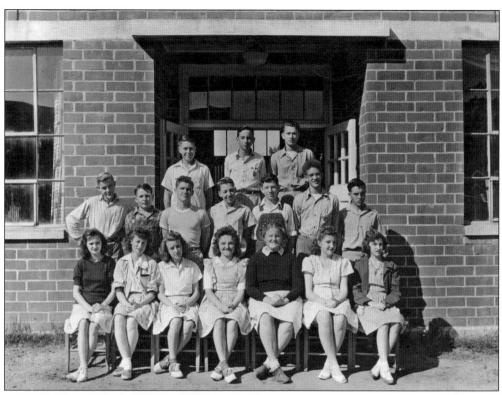

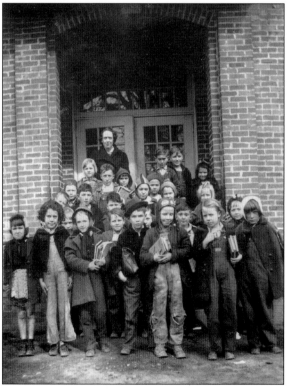

DULUTH SCHOOL, 1945. Students at Duluth School who would make up the class of 1948 gather for a photograph. They include, from left to right, (first row) Mildred Anglin, Bunnell Hamrick, Betty Daniels, Effie Mayhue, Bessie Gearmon, Margie Ruth Turner, and Selena O'Shields; (second row) Winfred Adams, Ben Robinson, Jack Mitchell, Joe McKelvey, Russell McKelvey, Jackie Parsons, and George Johnson; (third row) John Robinson, Donnie Sewell, and unidentified. (Courtesy of Kathryn Parsons Willis.)

DULUTH SCHOOL, EARLY 1940s. Standing with her students is teacher Myrtle Pittard. Ann Parsons is third from the left in the first row. (Courtesy of Kathryn Parsons Willis.)

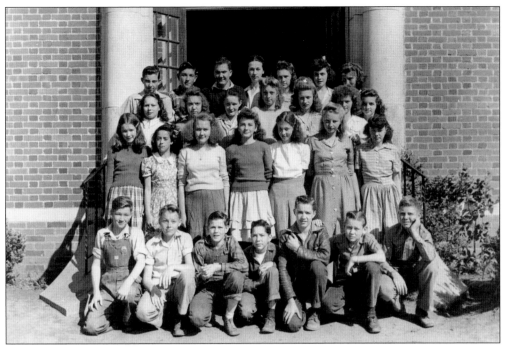

CLASS OF 1946. The class of 1946 gathers in the early 1940s for a photograph. Teacher Grace Findley Ellis is in the center in the fourth row. (Courtesy of Kathryn Parsons Willis.)

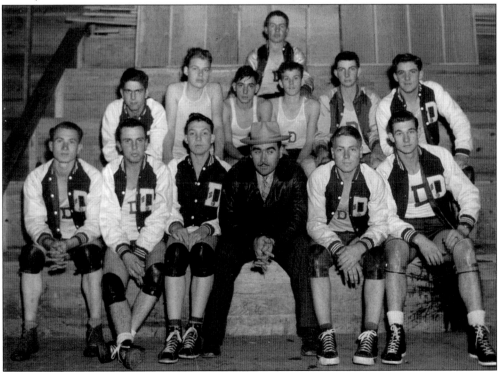

BASKETBALL TEAM. Duluth's basketball team is pictured in 1948. (Courtesy of Kathryn Parsons Willis.)

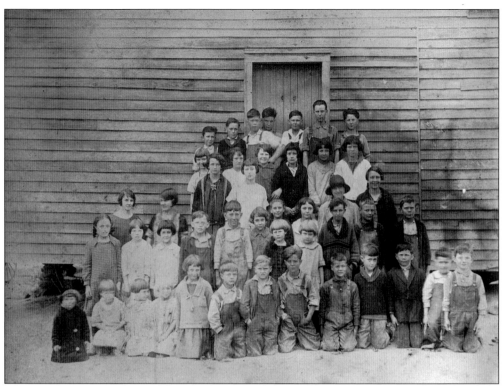

MEADOW SCHOOL. Students of the Meadow School, located between Lawrenceville and Duluth, gather for a photograph on the front steps of the school in 1924. (GWN 219.)

PLEASANT HILL ACADEMY. Students and faculty of the Pleasant Hill Academy gather for a group photograph. Standing behind the table are instructors Dr. Aubrey Sego Hopkins and Ezekiel Thomas Hopkins. (GWN 263.)

PITTMAN SCHOOL. Children and their teacher stand for a photograph at Pittman School south of Duluth in 1911. (Courtesy of GHS.)

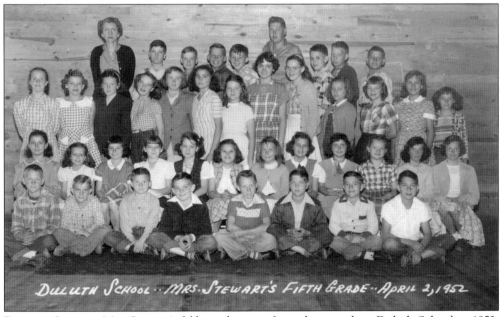

DULUTH SCHOOL · MRS. STEWART'S FIFTH GRADE · APRIL 2, 1952

DULUTH SCHOOL. Mrs. Stewart's fifth grade poses for a photograph at Duluth School in 1952. Duluth School housed all grades until 1958, when a high school was built. B.B. Harris Elementary opened in 1966. (Courtesy of Jimmy Martin.)

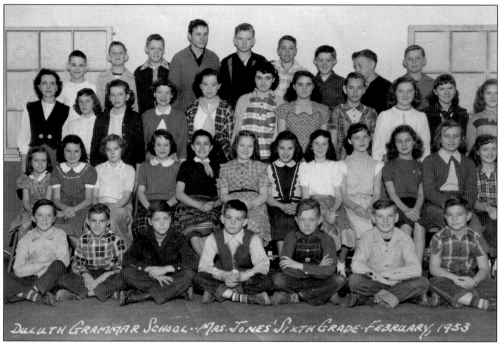

DULUTH SCHOOL. Mrs. Jones's sixth grade poses for a photograph at Duluth School in 1953. (Courtesy of Jimmy Martin.)

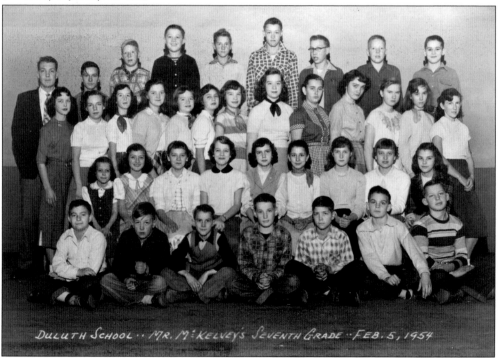

DULUTH SCHOOL, 1954. Joe McKelvey's seventh grade poses for a photograph at Duluth School. Jimmy Martin is the last student to the right in the first row. He and Joe McKelvey remain friends to this day, often meeting for coffee to laugh about old times. (Courtesy of Jimmy Martin.)

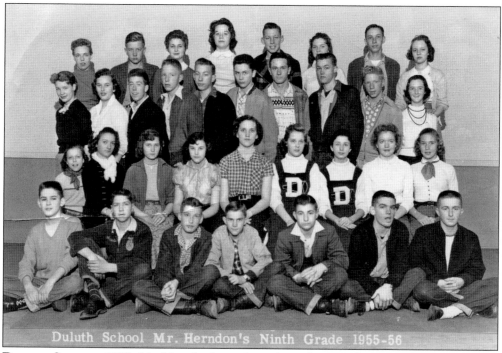

DULUTH SCHOOL, 1955. Mr. Herndon's ninth-grade students gather for a class photograph. (Courtesy of Jimmy Martin.)

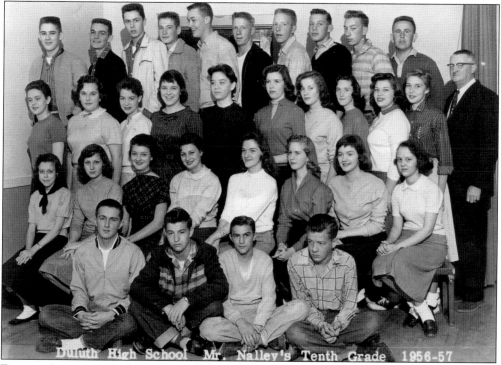

DULUTH SCHOOL, 1956. Mr. Nalley's 10th-grade students gather for a class photograph. (Courtesy of Jimmy Martin.)

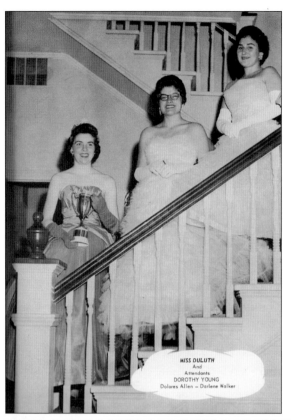

MISS DULUTH
And
Attendants
DOROTHY YOUNG
Dolores Allen — Darlene Walker

MISS DULUTH, 1957. Miss Duluth and her attendants, students at Duluth School, show off their best gowns. (Courtesy of Jimmy Martin.)

BASKETBALL TEAM. Pictured is Duluth School's basketball team of 1948. Eugene Brown, son of service station owner Allen Brown, is on the right. (Courtesy of Michael Brown.)

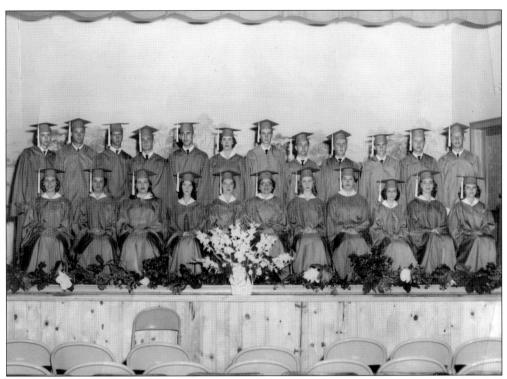

GRADUATING CLASS. Duluth High School's graduating class of 1959 is pictured here. The class graduated from the new high school, which was built in 1958. (Courtesy of Jimmy Martin.)

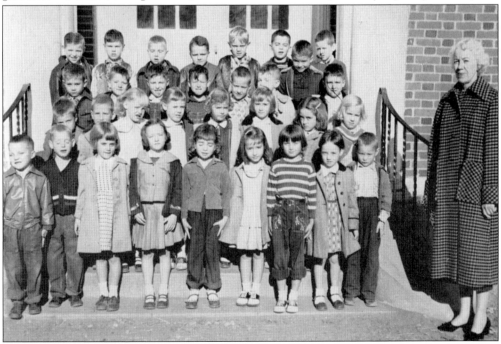

FIRST GRADE AT DULUTH SCHOOL, 1957. First-grade students pose with their teacher, Nelle Summerour. (Courtesy of Jimmy Martin.)

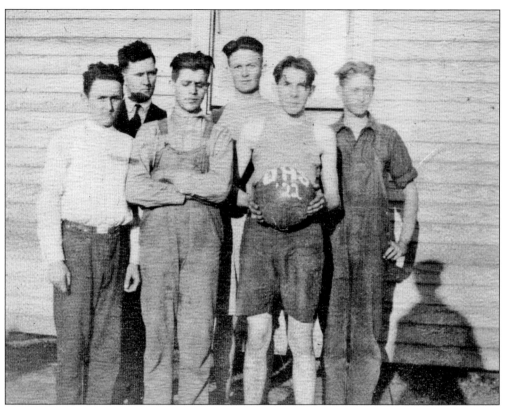

BASKETBALL TEAM OF 1922. With only five members, the 1922 boys' basketball team of Duluth School doesn't have much depth on the bench. (Courtesy of Michael Brown.)

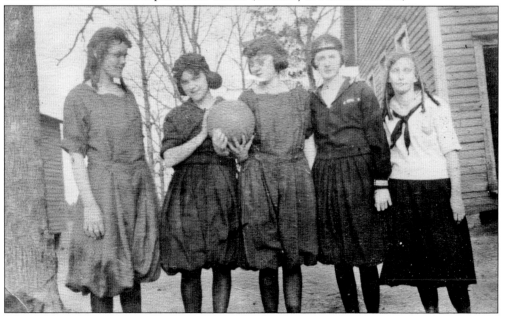

GIRLS' BASKETBALL TEAM OF 1922. Duluth School girls pose in their gym bloomers, the typical female (and modest) uniform in the early 20th century. (Courtesy of Michael Brown.)

FRIENDSHIP BAPTIST CHURCH. Friendship Baptist Church is one of the oldest black churches in Duluth. Many of its founders and congregation members came from the original families on the Hill: the Howells, Bowens, Brogdons, Shadburns, Rogers, Pooles, and Harrises. Some of the families are descendants of slaves who worked on the plantations near the Chattahoochee. After the Civil War, they provided services to the wealthier families in town. Among the notable women on the Hill were Lorene Mozelle Waters, 1923–2005; Lizzie Mae Poole, 1926–1999; and Mamie Howell. (Courtesy of the author.)

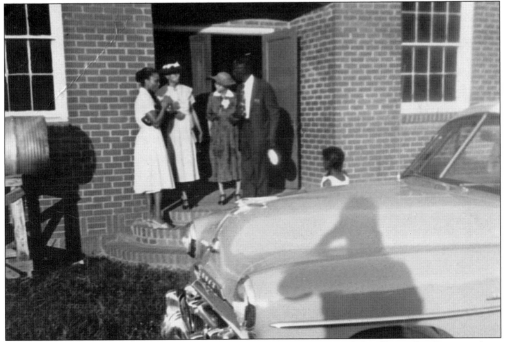

CHATTING AFTER CHURCH. Mamie Howell (center, second from right) talks with other members of Friendship Baptist Church in this photograph from 1959. The car in the foreground belonged to the pastor. The vestibule of the church has now been enclosed. (Courtesy of Willie B. Blake.)

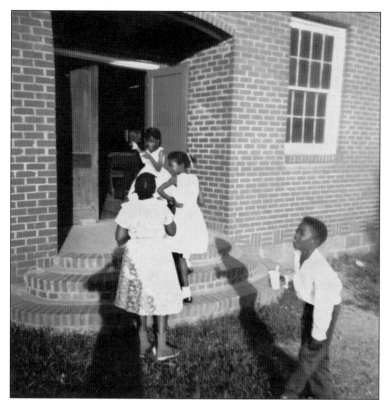

PLAY TIME. In the photograph at left, children play on the steps of the church after services. The church congregation outgrew the little church over the years, and in 2001, ground was broken for a larger church next door. (Courtesy of Willie B. Blake.)

LADIES OF THE CHURCH. Congregation members pose in front of the pastor's car in 1959. The ladies wearing hats carry on a tradition that goes on today in black churches. Local hatmakers still supply stylish hats to black women of all denominations. (Courtesy of Willie B. Blake.)

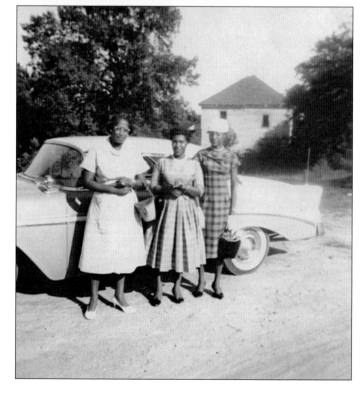

Best Buddies. Six little girls pose in their Sunday best after playing around the church while their parents socialize. (Courtesy of Willie B. Blake.)

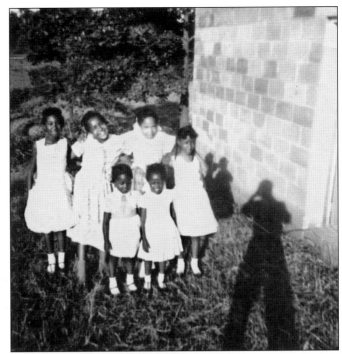

Baptism. Pastor Ronald Bowens of Friendship Baptist Church leads a young man into the baptismal pool. Pastor Bowens has been full-time minister of the church since 1991. Baptisms in the South often occurred at natural springs, ponds, and rivers. Seniors in Duluth remember a baptismal spring east of Duluth at the current location of Gwinnett Place Mall near I-85. (Courtesy of Friendship Baptist Church.)

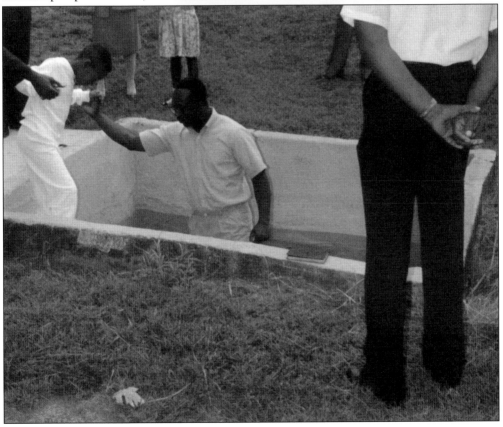

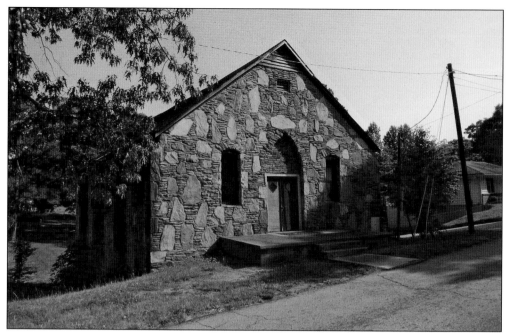

MOUNT ARARAT METHODIST EPISCOPAL CHURCH. Mount Ararat Methodist Episcopal Church is located on the Hill. It was organized in 1878, making it one of the earliest churches in Duluth. The rock structure shown in the photograph replaced the earlier church in 1921. Rev. P.H. Kelly was pastor of the new church. The structure is now abandoned. (Courtesy of the author.)

MOUNT CARMEL MISSIONARY BAPTIST CHURCH. Mount Carmel Missionary Baptist Church is an active congregation also located on the Hill. The church was organized as a congregation in 1858. It was rebuilt in 1978 under the leadership of Rev. W.F. Goodman. The Waters, a prominent family on the Hill, were active in the congregation, serving as deacons for many years. (Courtesy of the author.)

Six

LIVE, WORK, PLAY

Long before modern city planners began using the term "live, work, play" to define multipurpose communities, old town Duluth embodied the concept. Then, as now, folks gathered to picnic, play games, and complain about the weather. While there wasn't much time for leisure activities, square dances, holiday parties, family reunions, and church homecomings brought people together around good food and good conversation. Within the confines of this rural community, people gathered on Saturdays to shop downtown, celebrate in each other's homes with parties, attend church on Sunday, and rest on Sunday afternoon. Many longtime residents say they used to know the names of all the families and all the family members in any direction for five miles. Duluth folks looked out for their neighbors. It was small-town America.

Today, Duluth is no longer a small town, but the human events that occur here—weddings, graduations, work-place successes, and funerals—are as meaningful to its citizens today as in the past. This chapter is an illustration of some of the ways residents have lived, worked, and played in Duluth.

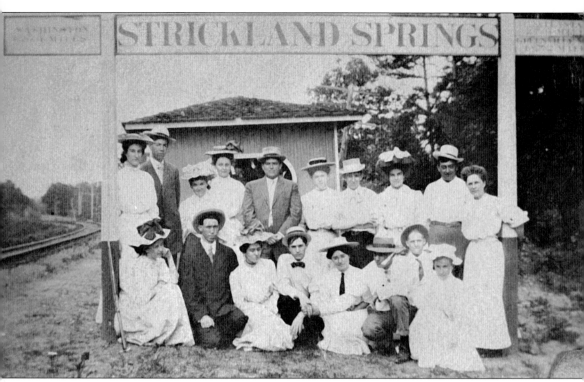

A Day at Strickland Springs. Visitors gather in 1910 at the Strickland Springs station two miles north of Duluth. The hotel and springs, located on 6,000 acres, was a popular getaway spot for Duluth residents and Atlantans wanting a day out of the city. Pictured visiting the resort are, from left to right, (kneeling) Stevie Brogdon, Brock Edmondson, Stell Harris, Marvin B. Verner, Viola Bennett, ? Norton, Ross Johnston, and Mabry Verner; (standing) Annie Lee Baxter, Marcus Mashburn, Winnie Little, Carfax Baxter, Hal Rhodes, Fannie Lou Patillo, Covert Harris, Villa Rhodes, Roy E. Johnson, and Clara Bennett. (GWN 121.)

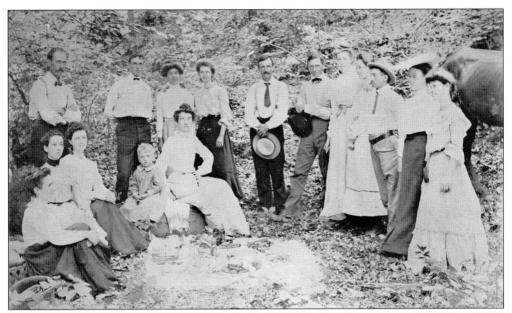

PICNIC. A group of well-dressed young women and men gather for a picnic in Duluth in 1895. This photograph may have been taken on a Sunday afternoon at Strickland Springs, a favorite time and place for picnicking in Duluth. (GWN 264.)

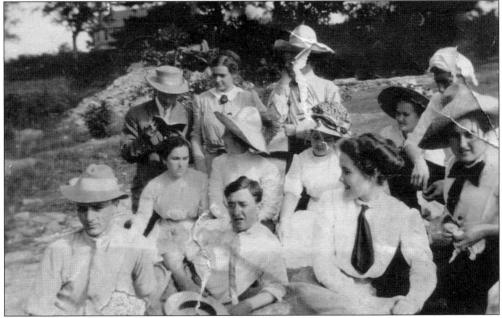

SOCIAL OUTINGS. A passenger train called the Belle transported Atlanta residents to the Strickland Springs flag stop, where passengers disembarked onto a special platform for hotel guests. Church groups often went to Strickland Springs for social outings, while local residents arrived by buggy or horseback to picnic on the grounds. The 22-room hotel, named for a group of eight bubbling springs that flowed from the hillside, was a large two-story white building that faced the railroad. After the hotel was destroyed by fire in the 1920s, vegetation began to grow around the spring, and the resort was lost to history. (Courtesy of Kathryn Parsons Willis.)

WAGON RIDE. A wagon ride at Strickland Springs in 1923 provides entertainment for this couple on a sunny afternoon. (Courtesy of Michael Brown.)

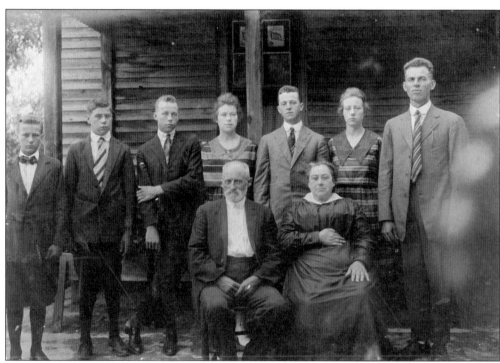

MARTIN FAMILY. The seven children of Mr. and Mrs. John Martin join their parents in the 1920s in front of the home place off Pleasant Hill Road. Included in this image are, from left to right, (first row) Mr. and Mrs. John Martin; (second row) Ernest, Charlie, Will, Lena, Roy, Lola, and John Martin. (Courtesy of Jimmy Martin.)

FAMILY PORTRAIT. Civil War veteran John Fulton Brown, his wife Sara Smith Brown, and their baby Cornelius lived in Howell's Cross Roads before it became known as Duluth. Brown ran a saloon in the center of town after the war. Scot Brown, one of his sons, established Duluth's first telephone company in the same building as the saloon. (Courtesy of Michael Brown.)

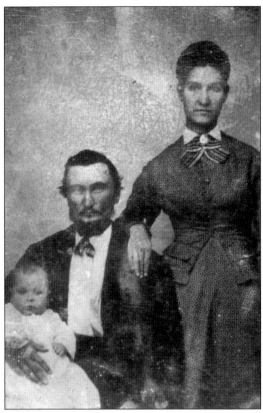

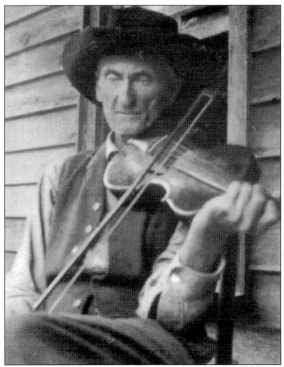

FIDDLIN'. John Fulton Brown (1845–1917) spent most of his life as a carpenter, building homes and caskets in Gwinnett County. Between the years 1903 and 1915, when an illness left him paralyzed and unable to walk, he put pen to paper, writing most of his life story in *The Bushwhackers: A Reluctant Rebel in the Civil War*. This image is from *The Bushwhackers*, published by iUniverse in 2008.

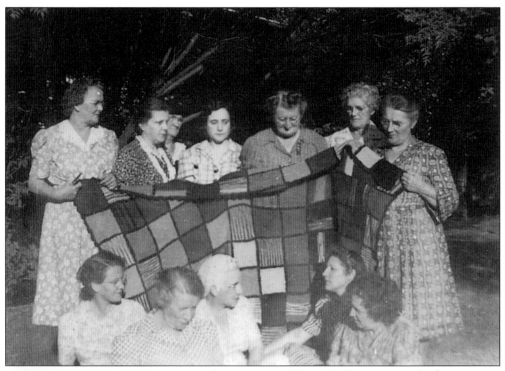

WOMEN'S HANDIWORK. Quilting, knitting, and sewing were popular pastimes for women, who often gathered in "bees" to work together. They may have gossiped just a little bit, too. (Courtesy of Kathryn Parsons Willis.)

HATTIE AND CALVIN PARSONS. Hattie and Calvin Parsons lived in a Victorian home built in 1897 on a 1,200-acre farm. Calvin also had a cotton gin, a cannery, and a gristmill in Duluth. He was Sunday school superintendent and Hattie was pianist at Warsaw Methodist Church for over 50 years. They were the parents of Parsons store owner Calvin Parsons and grandparents to Ann, Kathryn, and Margaret Parsons. The Parsons are descendants of Evan Howell, Duluth's founder. (Courtesy of Kathryn Parsons Willis.)

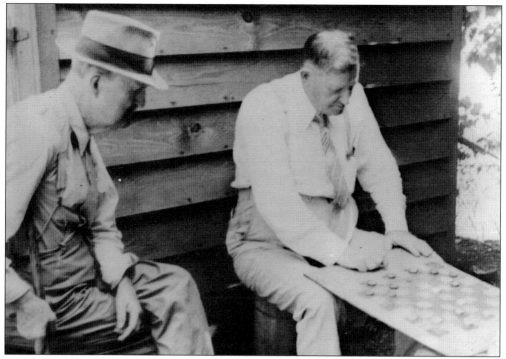

A Friendly Game of Checkers. John Knox and Joe Mitchell play their ongoing game of checkers at Mitchell's shoe repair shop. Knox was elected the first mayor of Duluth in 1880 and was a founder of the Methodist church. (Courtesy of Kathryn Parsons Willis.)

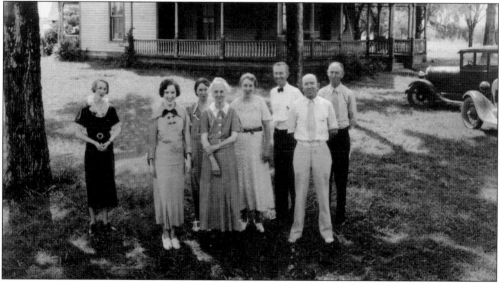

Summerour Family. The Summerours were among the founding families of Duluth. Here, Mrs. C.W. Summerour is surrounded by her children in the 1930s at their Abbotts Bridge Road home in Duluth. In this photograph are, from left to right, Nelle, Charlotte, Mrs. Summerour, Ruth, Susie, Charlie, Heard, and Harrison. Another sister, Kate, cut out her likeness and is not shown. Heard Summerour was the Duluth postmaster and Sunday school superintendent for many years. (Courtesy of GHS.)

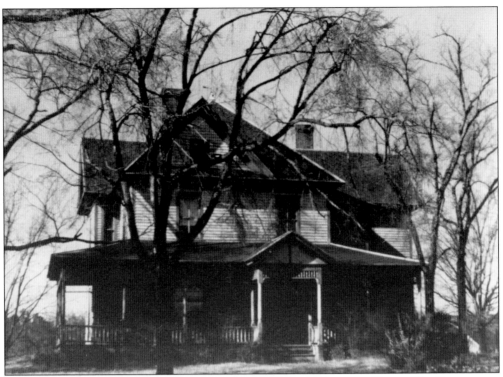

SUMMEROUR HOME. The Summerour home on Abbotts Bridge Road was large enough to accommodate a family with numerous children. (Courtesy of GHS.)

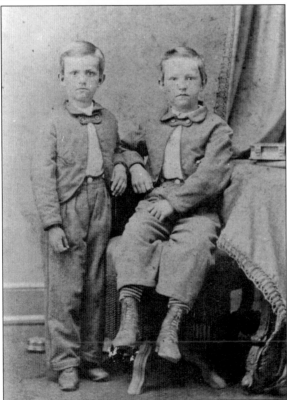

CLEANED UP. The Parsons brothers, dressed in identical outfits, have cleaned up, combed their hair, and put on their best clothes for this portrait taken in the 1860s. On the left is Calvin McClung Parsons, and on the right is Jackson Augustus Parsons. Calvin's son, also named Calvin, founded Parsons general store in Duluth. (Courtesy of Kathryn Parsons Willis.)

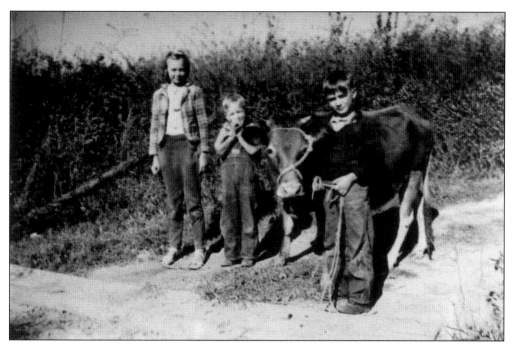

ON THE FARM. Children lead Bessie back to the barn in this image. (Courtesy of Kathryn Parsons Willis.)

BABY CALVIN. Calvin Parsons was born in 1896. He founded Parsons, a large general store on Main Street in Duluth, in 1925. He and his wife, Kate, had three daughters, all of whom worked in the store and continue the family business today but in different locations. Kate also helped to run the store and was active in civic affairs in Duluth. Calvin and Kate kept the store shelves stocked with dry goods, groceries, hardware, feed, fabrics, and building materials. Farmers would often bring in eggs, chickens, and vegetables and trade them for merchandise. The Main Street store closed in 1987. (Courtesy of Kathryn Parsons Willis.)

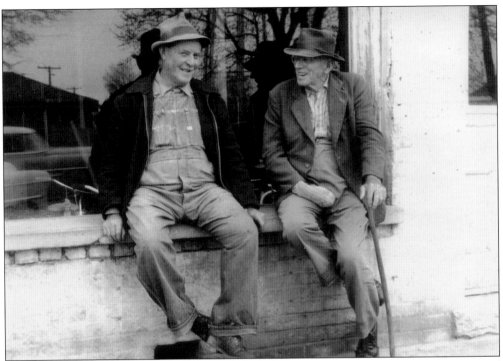

PASSING THE TIME. The window ledges of Parsons store provided a place for passing the time and discussing the urgent business of the day. Benches on the opposite side of the street under a row of maple trees were known as the "liars benches." They provided a place for older men to "set a spell" and offer some education to the younger men in town. (Courtesy of Kathryn Parsons Willis.)

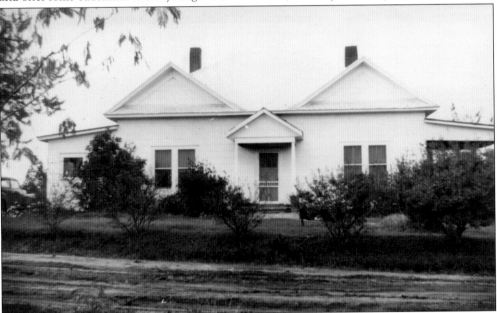

BROWN HOME PLACE. The home of service station owner Allen Brown and his wife, Gladys, provided a summer haven for grandson Michael Brown, who remembers following his grandfather around town. (Courtesy of Michael Brown.)

SNOW, 1936. A layer of snow, always a rarity for this community north of Atlanta, covers the ground at the Findley house on Main Street in Duluth. (Courtesy of Kathryn Parsons Willis.)

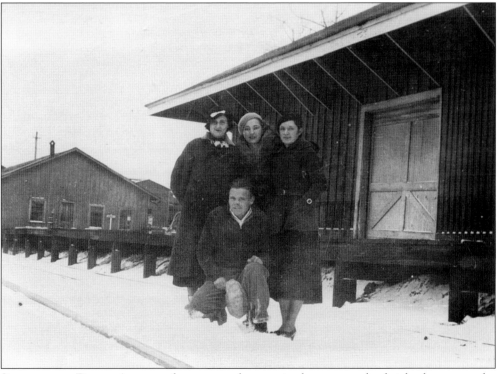

SNOW AT THE DEPOT. A group of young people poses in the snow at the freight depot near the railroad. Warehouses can be seen in the background. (Courtesy of Kathryn Parsons Willis.)

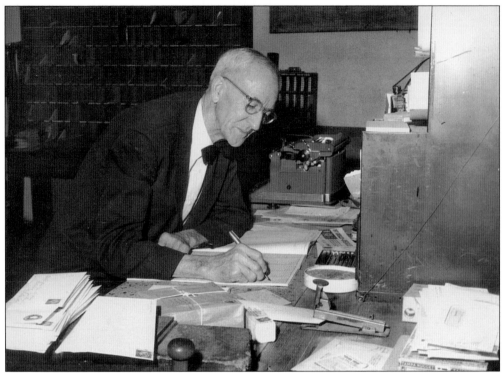

MR. HEARD. Heard Summerour, Duluth postmaster and Sunday school superintendent, makes notes in his ledger at the post office. Summerour, known as Mr. Heard, was beloved by many. He was among the leaders in town who were instrumental in establishing Joan Glancy Hospital. (Courtesy of Kathryn Parsons Willis.)

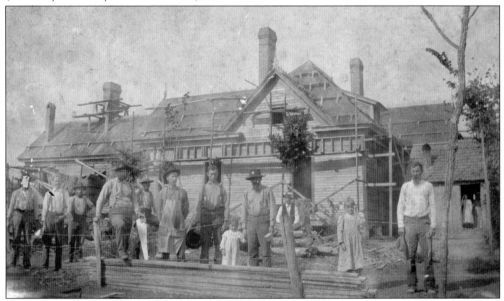

PARSONS HOME PLACE. The old Parsons home, three miles from downtown, is pictured during its construction in 1896. A photograph taken more than 100 years later can be seen on page 89. (Courtesy of Kathryn Parsons Willis.)

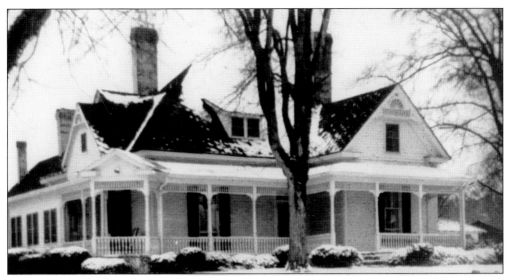

A CENTURY LATER. In this photograph, little has changed at the Parsons home place. The home has since been moved to Parsons Road near Duluth but is still in the family. (Courtesy of Kathryn Parsons Willis.)

DR. JOHN E. CHRISTIAN. Dr. John Christian, a beloved physician in Duluth, is shown in this photograph, taken around 1900. His office was located next to his house. Dr. Christian practiced in Duluth for almost 40 years. He was often paid in eggs or other farm goods. Dr. Christian married Mattie Pendergrass, who had a twin sister named Hattie who married Calvin McClung Parsons Sr. Their descendants live in Duluth today. (Courtesy of Kathryn Parsons Willis.)

HOME TO DULUTH LEADER. This painting by Ann Parsons Odom depicts one of the oldest houses in Duluth. It was constructed around 1850 and was the home of Singleton Howell, son of Duluth's founder. Later, it was home to Dr. John Christian and his wife, who lived here for many years. (Courtesy of Ann Parsons Odum.)

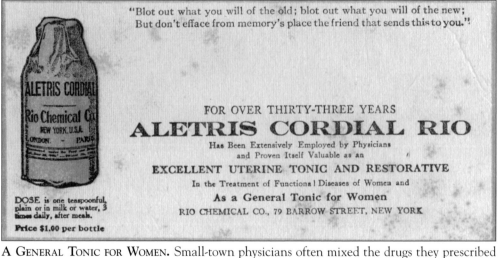

A GENERAL TONIC FOR WOMEN. Small-town physicians often mixed the drugs they prescribed to their patients. Other drugs, such as tonics for women's diseases, were ready-made and often contained alcohol. (Courtesy of the Duluth Historical Society.)

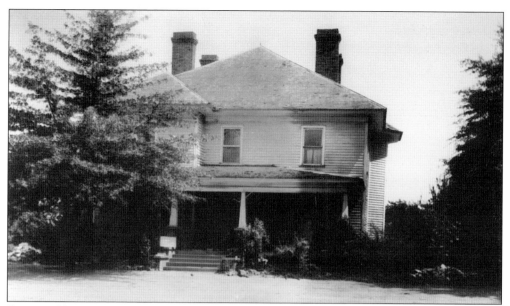

DULUTH HOTEL. Dr. M.T. McDaniel and his wife, Geneva O'Kelly McDaniel, purchased the old Duluth Hotel in the early part of the 20th century. They used the house as their residence, although part of the house functioned as Dr. McDaniel's medical office . Geneva McDaniel lived in the house until she was over 100 years old. (Courtesy of the Duluth Historical Society.)

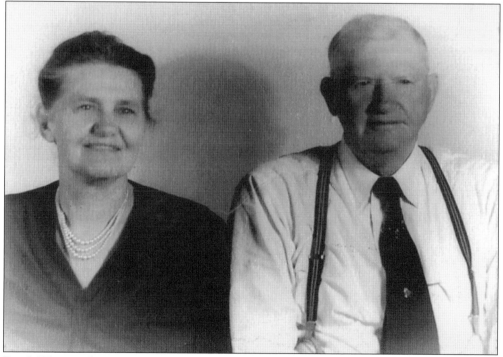

DR. M.T. AND GENEVA MCDANIEL. Geneva McDaniel came to Duluth in 1907 to teach at Meadow School House, which was between Lawrenceville and Duluth. Her salary was $40 a month. Later, she became one of Gwinnett County's largest landowners. (Courtesy of the Duluth Historical Society.)

A BOY AND HIS BIKE. A young George Bennett in knickers and tie shows off his new bicycle. (Courtesy of Jeanne Hall.)

BENNETT HOME PLACE. George Bennett was raised in this single-story frame dwelling in Duluth. The house was originally built with filigree decorative elements on the porch and roof at the turn of the 20th century. (Courtesy of Jeanne Hall.)

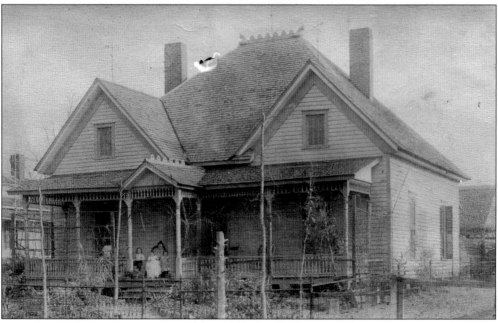

YOUNG GEORGE. A young George Bennett poses for a formal portrait. (Courtesy of Jeanne Hall.)

STEVIE LIVELY BENNETT. Stevie Lively holds her diploma and a bouquet of roses in this graduation photograph. She had a most unusual name—Stevie Steven Lively. Her parents, convinced that they were having a boy, refused to give her a girl's name after she was born. She married George Bennett and worked with him in his business ventures. He eventually helped her establish a florist shop in Duluth. (Courtesy of Jeanne Hall.)

CHEF BENNETT. For a time, George operated George's Café in Duluth. It was first located on the corner of Buford Highway and SR 120 in the early 1940s. Later, he moved the café to Main Street. (Courtesy of Jeanne Hall.)

FRESH CHICKEN. Patrons would sometimes get a very fresh meal at George's Café. If the restaurant was out of chicken, Bennett or Stevie would go next door to Granny Bennett's house and kill one. (Courtesy of Jeanne Hall.)

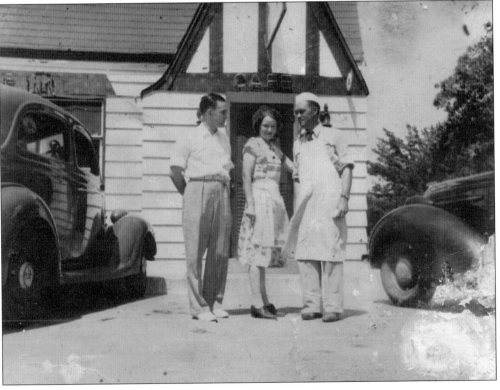

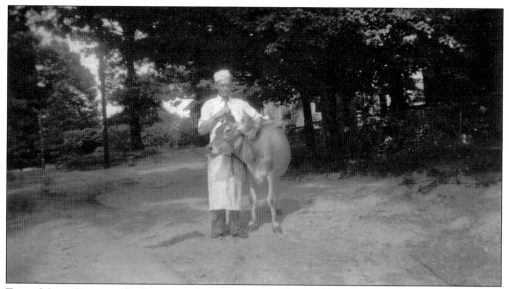

FRESH MILK. George milked a cow each morning so that he could serve fresh milk in the restaurant. (Courtesy of Jeanne Hall.)

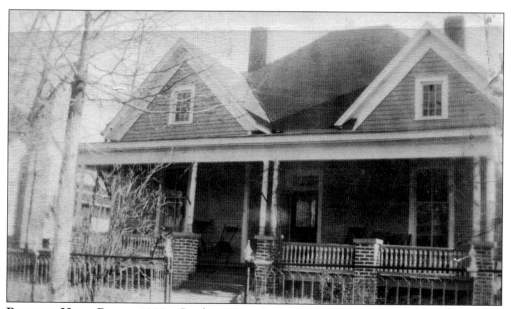

BENNETT HOME PLACE, 1930s. By the 1930s, the fussier Victorian elements were gone, and the house features a simpler look, including sturdy brick piers that replaced the delicate turned columns. (Courtesy of Jeanne Hall.)

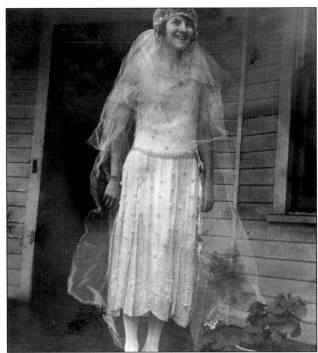

WEDDING DAY. Ruthe Gladys Webb of Alpharetta is a beautiful bride on her wedding day in 1926. She married E.A. Brown and settled in Duluth, where she worked as a schoolteacher. (Courtesy of Michael Brown.)

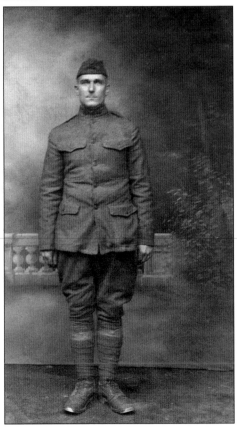

DOUGHBOY. E.A. Brown left Duluth to serve in World War I. Here, he is pictured in his uniform in 1918. When he returned to Duluth, he opened a gas station. (Courtesy of Michael Brown.)

MARY E. SUMMEROUR. The Summerours were among the founding families in Duluth. After settling in the area in the 1800s, they went on to become teachers, business owners, and church and civic leaders. (Courtesy of Michael Brown.)

ON HER WAY. With her wagon, hat, and big pockets, this little girl is ready to do some shopping downtown. (Courtesy of Michael Brown.)

ALLEN PITTARD. Allen Pittard looks like a studious young man in this undated photograph. Denim overalls were typical attire for rural boys and girls before World War II. (Courtesy of Michael Brown.)

WASH DAY ON THE HILL. Until wringer washers were invented, wash day usually fell on Monday and was an all-day affair. Family clothes were washed in a big pot full of boiling water and lye soap. Sometimes paid help was used to get the laundry done, especially if the family was large and could afford to employ someone. In this undated photograph, a family on the Hill prepares for laundry day. (Courtesy of Kathryn Parsons Willis.)

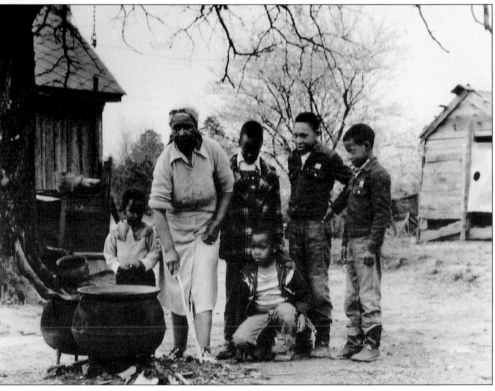

LEVI NASH. Nash was employed as the school janitor at Duluth School until his death. He lived near the school in an old frame house that became Joan Glancy Hospital. City fathers built a new house for him. (Courtesy of Kathryn Parsons Willis.)

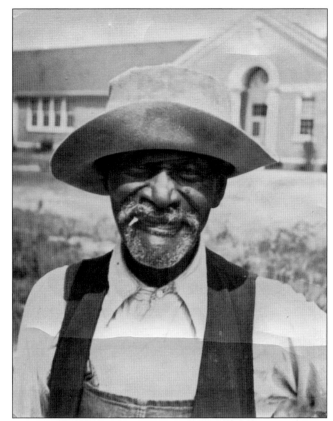

CONTEST DRAWS A CROWD. A drawing to win a free bale of cotton attracted hundreds of people to downtown Duluth on this Saturday in 1934. (Courtesy of Kathryn Parsons Willis.)

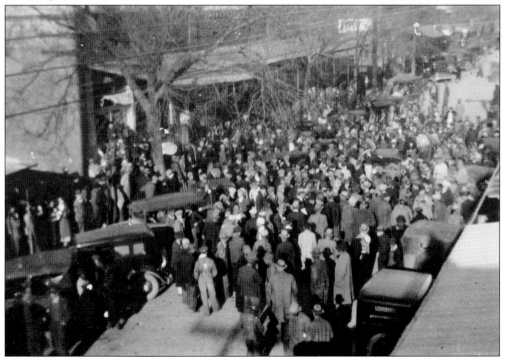

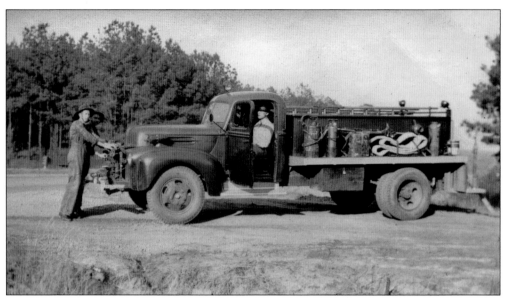

DULUTH VOLUNTEER FIRE DEPARTMENT. Firefighting in Duluth in the 1930s consisted of this truck and equipment manned by volunteers. (Courtesy of Michael Brown.)

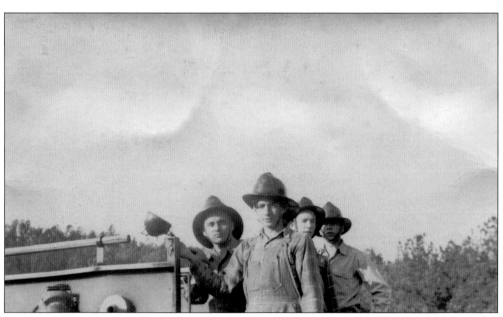

TRAINING. These young volunteer firefighters train for emergency calls. The wooden structures and warehouses full of goods near the railroad made Duluth a fire hazard. (Courtesy of Michael Brown.)

UNCLE BENDY. "Uncle Bendy," a beloved Duluth resident, spent a lot of time in downtown Duluth, and everyone knew him. (Courtesy of Kathryn Parsons Willis.)

LADIES IN CHARGE. The women gathered here were the movers and shakers of Duluth society in the 1940s and 1950s. They ran their homes, the schools, and the churches. They include Ellyne Strickland, Lily Summerour, Myrt Payne, Martha Pittard, Grace Boles, and Grace Ellis. (Courtesy of Kathryn Parsons Willis.)

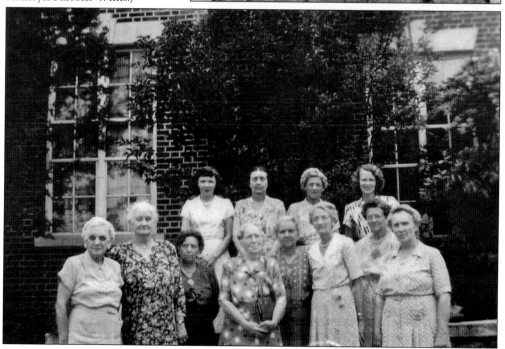

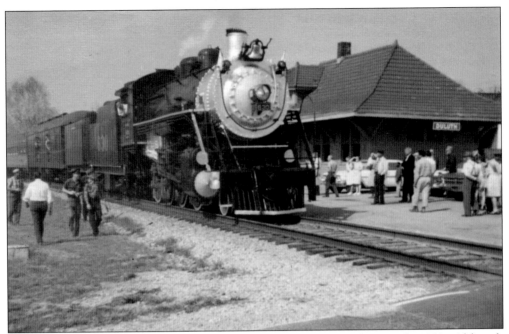

LIKE BYGONE DAYS. A steam engine impresses people at the passenger depot in the 1950s. Although steam engines were a common sight in Duluth's old days, by the 1950s, they were relics of the past. (Courtesy of Kathryn Parsons Willis.)

ALL THAT'S LEFT. By the 1950s, most of the warehouses and cotton gins that had lined the railroad had either burned or been torn down. Until the mid-20th century, however, trains were commonplace, particularly as there were double tracks from Atlanta to Gainesville. During World War II, it was said that a train came through Duluth an average of every 11 minutes. Many of them were troop trains or freight trains carrying war equipment and supplies. (Courtesy of Kathryn Parsons Willis.)

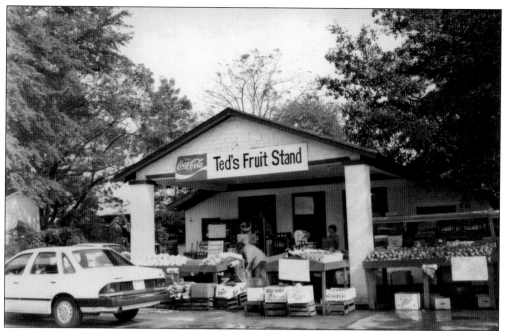

TED'S FRUIT STAND. Ted's Fruit Stand, located in an old service station, was a landmark on Buford Highway before it was demolished in 1989 when the highway was widened. Local residents often stopped by to purchase fruit or vegetables and, in the winter, Ted's popular boiled peanuts. (Courtesy of CoD.)

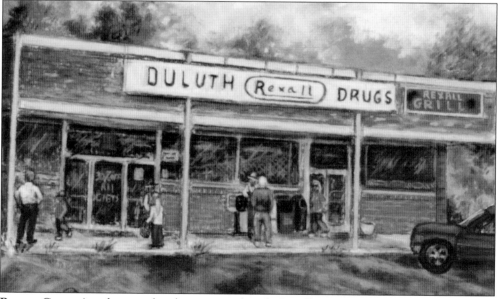

REXALL GRILL. Another popular place to meet friends, Rexall Drugs and Grill is still standing and just as busy as ever. The drugstore opened in 1969, and the grill was added soon thereafter. The building burned in 1993 but was rebuilt. If local politicians wanted to know how Duluth folks felt about an issue, all they had to do was eat lunch at the grill and they would get an earful. Today, many of the regulars are gone, but the grill has found new life with nearby office workers looking for a good burger or grilled cheese sandwich for lunch. (Courtesy of Ann Parsons Odom.)

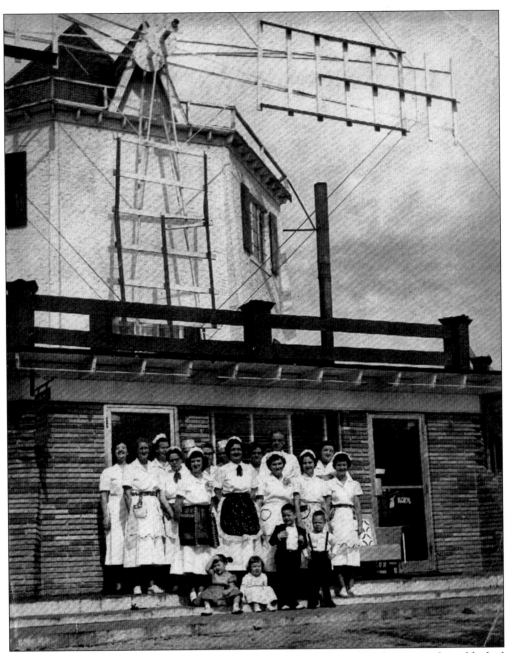

A WINDMILL IN DULUTH. Tourists driving south to Atlanta on Buford Highway must have blinked twice at the sight of a windmill, complete with turning blades, in Georgia. The Dutch Inn was the inspiration of Lowry and Lenora Arnold, who built the place with their own hands, painted it white with blue trim, and opened it to the public in 1948. It was operated first as a drive-in and later as a sit-down restaurant. Lowry Arnold thought the turning windmill blades would attract the motoring public, enticing them off the road. It was a tradition for many in Duluth to go to church on Sunday and then eat a dinner of fried chicken or barbecue at the Dutch Inn. (Courtesy of the Duluth Historical Society.)

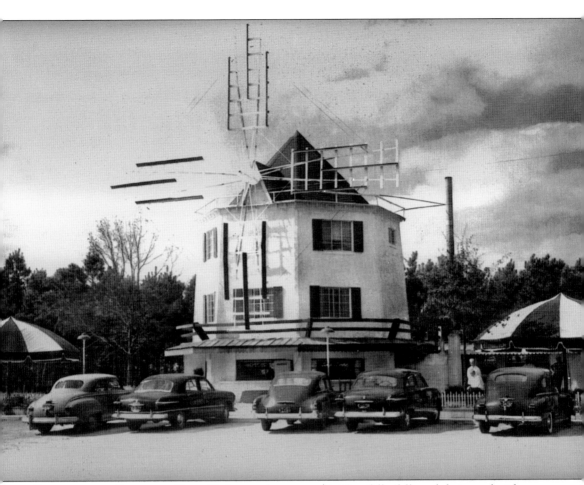

BARBECUE AND PINEAPPLE CAKE. Barbecue plates were $1. Most folks followed their meal with a piece of the Dutch Inn's famous pineapple cake, the recipe for which is printed below. (Courtesy of the Duluth Historical Society.)

Pineapple Cake from the Dutch Inn

(This recipe has been handed down by Jean Ann Corley and Dot Arnold Turner, daughters of Lenora Arnold. This cake was baked every day for patrons of the Dutch Mill.)
Cream 1 cup Crisco and 2 cups of sugar
Add 4 eggs, one at a time, mixing after each
Add 1 teaspoon of vanilla to 1 cup whole milk
Alternate adding 3 cups self rising flour and the liquid to the Crisco and egg mixture
Begin and end with dry ingredients
Divide the batter into 3 greased and floured 9-inch pans and tap filled pans on the counter to ensure even rising
Bake at 350 degrees until center springs back

Icing

Use a 3 quart or larger boiler because this icing will boil over. Combine 3 cups of sugar with 2 cups of milk. Bring to a rolling boil and cook to a soft ball stage. DO NOT STIR. This can take from 20 to 30 minutes. Remove from heat and gently fold in one can of drained crushed pineapple. Spoon onto warm cake layers as you punch holes here and there and stack the cakes one on top of another.

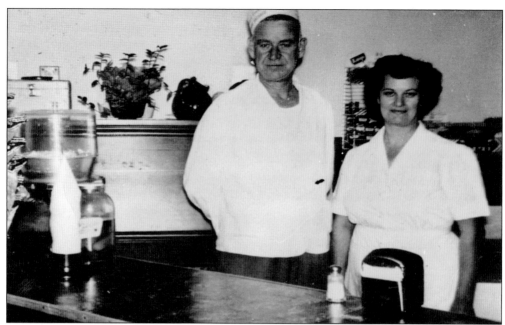

LOWRY AND LENORA ARNOLD. The owners of the Dutch Inn stand behind the counter in a 1940 photograph. The Dutch Inn operated for many years but has been torn down and replaced by a bank. A different meeting place in Duluth in the 1950s, especially for teenagers, was the Frosty Bar, where patrons could get two-for-a-quarter milkshakes, sundaes, hot dogs, and chili dogs. The building where the Frosty Bar was located is still standing, but the restaurant is no longer in business. Other popular restaurants were the Foxworth Café and Smitty's. (Courtesy of the Duluth Historical Society.)

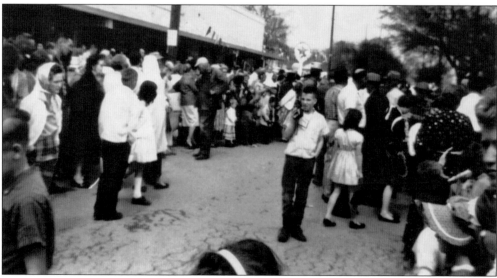

CENTENNIAL, 1962. Crowds gather on Main Street for the Duluth Centennial in 1962. It was a five-week affair, with most events occurring on Saturdays. Though this festival was dubbed a centennial, Duluth itself was not 100 years old until 1971, which was 100 years after the name was changed from Howell's Cross Roads to Duluth. The centennial event was a precursor to the Duluth Fall Festival, which has been held every year since 1983. (Courtesy of Kathryn Parsons Willis.)

SOUTHERN BELLES AND GENTLEMEN. The volunteers who worked the centennial dressed in period costume. The only exception was the men's hats, which were marked "Duluth Centennial" in glitter. Any male volunteers who did not grow a beard for the festival were playfully whisked off to the Calaboose. (Courtesy of CoD.)

FULL BODY CAST. One of the most unusual participants in the centennial parade of 1962 was 20-year-old Jimmy Martin, who had been shot in the hip in a hunting accident. He spent six months recuperating in the hospital but still returned to Duluth in a full body cast. He was tucked into the bed of a pickup truck and driven down the parade route, along which he waved to hundreds of well-wishers. (Courtesy of Jimmy Martin.)

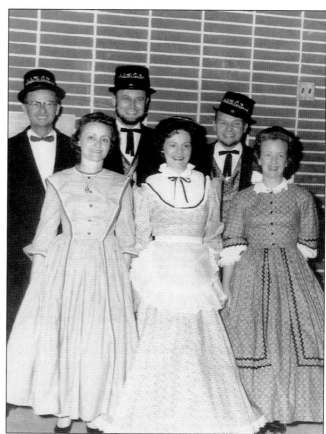

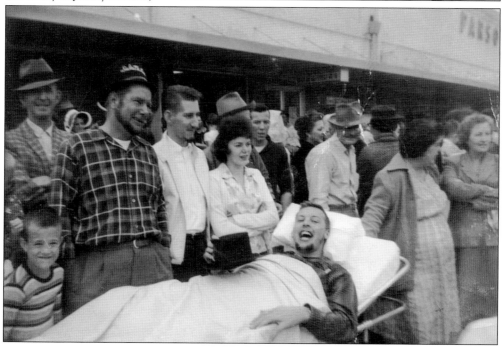

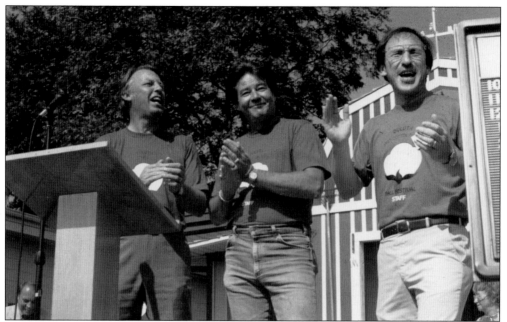

26 Years Later. In 1988, Martin (left), minus the body cast, joins Charlie Wynn (center) and Brooks Coleman (right) for a rousing rendition of "I Love Duluth" at the 1988 Duluth Days, a celebration that would become the Duluth Fall Festival. Martin wrote the lyrics of the song, which Wynn set to music. (Courtesy of Jim Martin.)

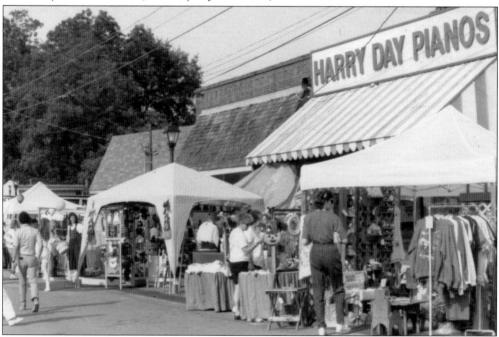

Duluth's Fall Festival. The Duluth Fall Festival, held the last weekend in September, offers more than 350 arts and crafts and food booths and draws crowds greater than 80,000. Proceeds from the festival helped raise money for the city's new Festival Center building and amphitheater. (Courtesy Kathryn Parsons Willis.)

THE CHICKEN OF TOMORROW. One of Duluth's little-known contributions to American cuisine is the development of the Vantress white male line of chickens, still the dominant line in the poultry industry. In the late 1940s, the A&P Grocery Company suggested that poultry breeders concentrate on meat yield rather than pure-breed characteristics in chickens. A Chicken of Tomorrow contest was established to develop a chicken that would eat the least amount of feed, grow the fastest, and dress out to a completely standard bird with a minimum of waste. Contestants, including one from Duluth, traveled to Arkansas to be present when the winner was announced. (Courtesy of the University of Arkansas Department of Agriculture.)

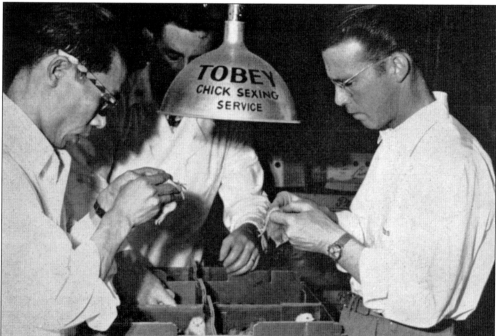

CHICKENS ARE SEXED. Before the contest winner could be announced, chickens had to be sexed. (Courtesy of the University of Arkansas Department of Agriculture.)

CHICKENS ARE WEIGHED. The Chicken of Tomorrow contest was held in 1951 at the University of Arkansas and featured 45 contestants from 25 states vying for the first-place award. More than 30,000 people attended the festivities, which included a parade, rodeo, and barbecue. After chickens were sexed and brought to maturity, they were weighed. (Courtesy of the University of Arkansas Department of Agriculture.)

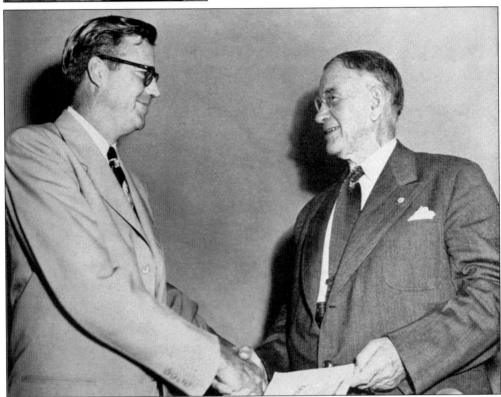

AND THE WINNER IS . . . The first place winner in the contest was Charles Vantress, whose headquarters were in Duluth, Georgia. The Vantress facility raised about three million roosters a year. Vantress won $5,000 and a first-place trophy for his Cornish–New Hampshire crossbred entry. US vice president Alben Barkley, right, presented the award. Vantress became a leading broiler breeder company and was later acquired by Tyson Foods. Vantress, operating today as Cobb-Vantress, is still a market leader, supplying broilers to more than 60 countries. (Courtesy of the University of Arkansas Department of Agriculture.)

MARY FINDLEY. Mary Findley, shown in 1961, came from a family of longtime Duluth citizens. The Findleys were among the founders of the town in the 1800s. (Courtesy of Michael Brown.)

GOOD EATING. Few could turn down a fresh cold watermelon in the summer, and a family gathering is always a good excuse for serving it. (Courtesy of Michael Brown.)

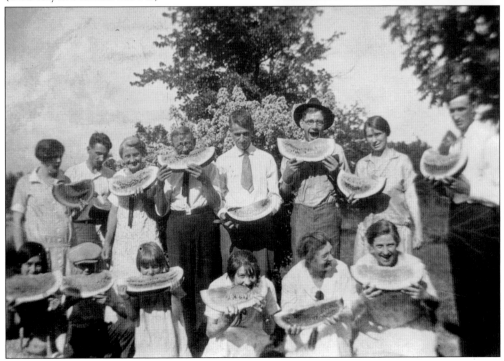

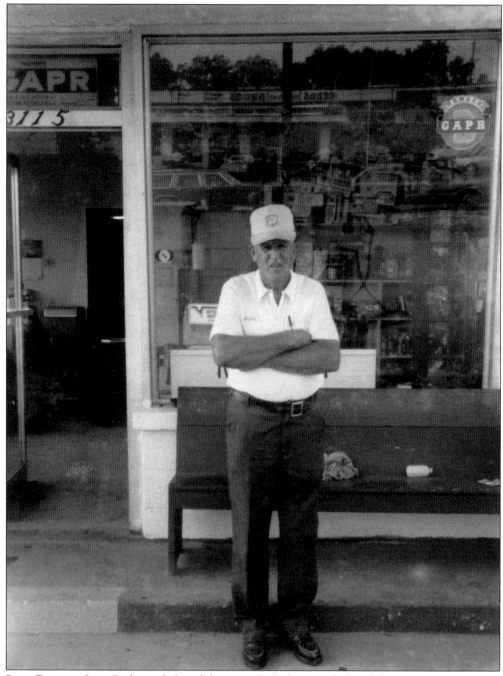

IVAN BARKER. Ivan Barker, a beloved figure in Duluth, owned the Phillips 66 service station downtown. His murder in the 1950s shocked the citizens of Duluth. The murder was never solved. (Courtesy of Kathryn Parsons Willis.)

A Dentist for Duluth. After World War II, newcomers moved into Duluth to establish new services and raise their families. One of these couples was Mary and Wallace Lail, who arrived in town when Mary was 28 and Wallace was 29. Dr. Lail, a dentist newly out of the US Army, established the second dental practice in the city and the eighth in Gwinnett County. Lail hung out his shingle and the couple held their breath, as they only had their last Army check to tide them over. Like other newcomers, they joined civic organizations, made new friends, and watched their children thrive in the growing community. (Courtesy of Mary Lail.)

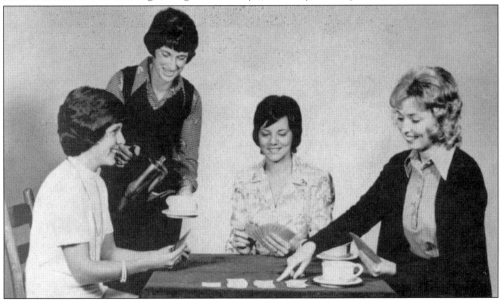

Ladies Lunch. Newcomers to Duluth soon met other residents like this group of women with school-age children who often met for lunch. They established an informal wedding and baby shower event group known as the Duluth Community Shower Ladies and ushered children from one activity to another. In this photograph are, from left to right, Pat Kesmodel, Barbra Hartley Davenport, Barbara Martin, and Mary Ann Anderson. Mary Lail took this photograph for her book of poetry *Thoughts for Caring and Sharing.*

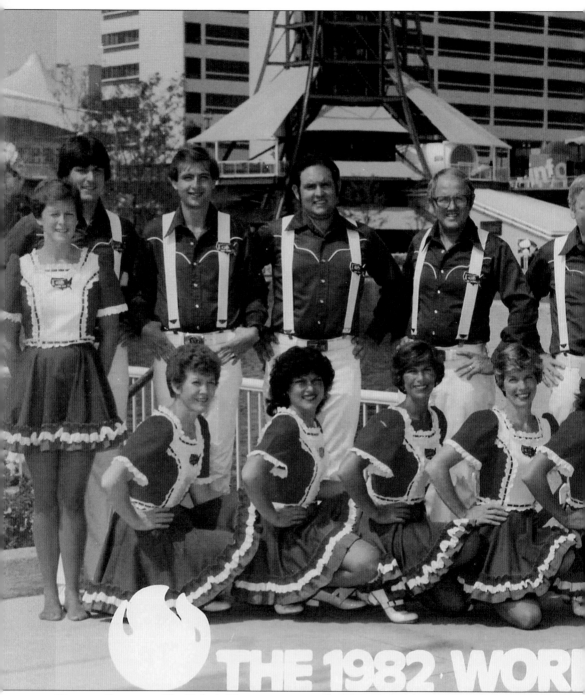

DULUTH CLOGGERS. The Duluth Cloggers, active in the 1970s and 1980s, were Southeastern U.S. Champions. Formed by Bob Schell, they practiced their precision clogging routines in an old chicken house. They were busy for 10 years as a traveling team, opening for Kenny Rogers and

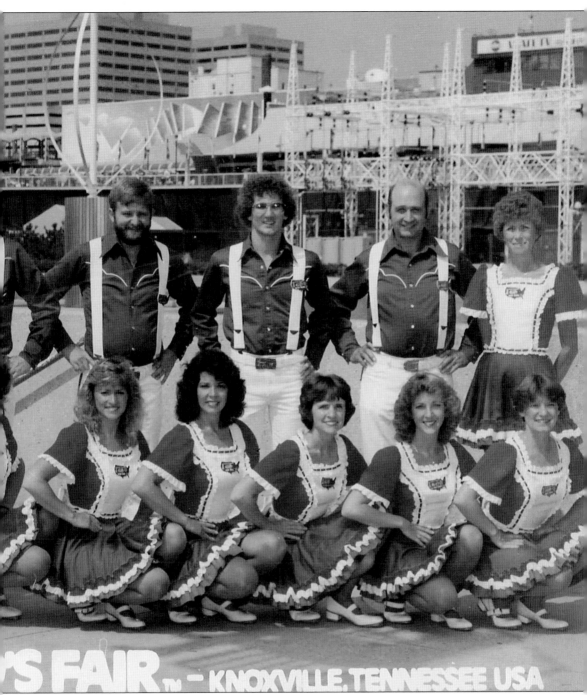

Larry Gatlin and appearing on the Dinah Shore Show and at the 1982 World's Fair. Team members included Bob Schell, Gail and Mack Bell, Kay Willis Montgomery, Kathryn Parsons Willis, Mary and Wallace Lail, Buck Johnson, Faye Smith, and Rita Bell. (Courtesy of Mary Lail.)

TAKING IT EASY. As the newcomers moved in and established themselves, others from the 1950s and 1960s began to take it easy. "Papa and Mama" (Leonard and Hazel) Anglin, owners of the Frosty Bar, a bowling alley, and a skating rink, enjoy their retirement. (Courtesy of Mary Lail.)

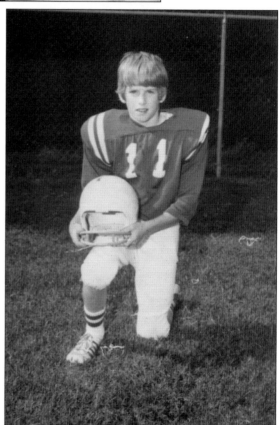

ANOTHER GENERATION OF FOOTBALL PLAYERS. Football is always a draw for young men. Ray Lail played on the Duluth Little League football team in 1971. (Courtesy of Mary Lail.)

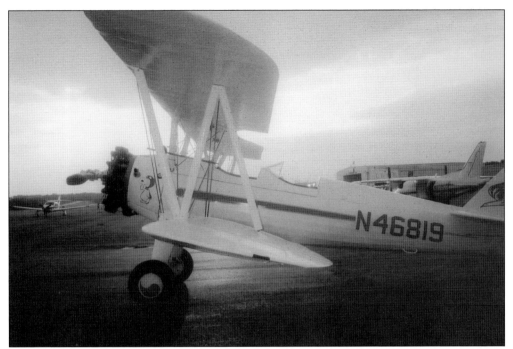

THE REAL THING. Dentist Wallace Lail made good use of his attention to detail by restoring a Stearman biplane. The open-cockpit plane is the real thing, having been used as a trainer in World War II. After he purchased the airplane in the 1980s, Lail flew it from Miami, Florida, to the Gwinnett County Airport. (Courtesy of Mary Lail.)

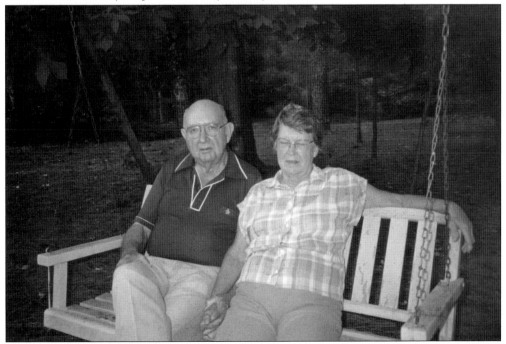

DULUTH SURGEON. Dr. George Tootle, a Duluth surgeon for many years, enjoys a relaxing backyard swing. (Courtesy of Mary Lail.)

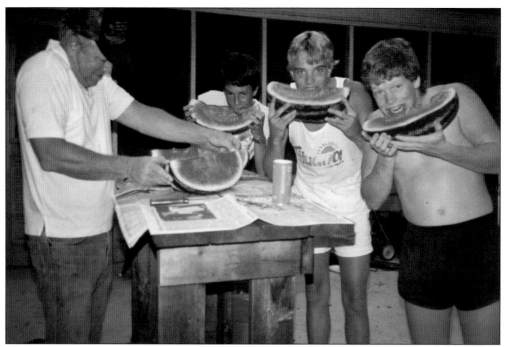

SUMMER TREAT. Watermelon has always been a treat in the South during the hot months of summer. Enjoying a juicy melon in 1980 are, from left to right, Wallace Lail, Kevin Calloway, Eddie Anglin, and Slade Lail. (Courtesy of Mary Lail.)

WHAT'S OLD IS NEW AGAIN. Mary and Wallace Lail once again enjoy riding in a 1957 Chevrolet, thanks to a gift from their sons. The Lails courted in a 1957 Chevy and left for their honeymoon in the same make of car. After the Lails moved to Duluth, they raised five sons and now have 10 grandchildren, all of whom live in Gwinnett County. (Courtesy of Mary Lail.)

Seven

DULUTH ON THE MOVE

After World War II, Duluth was overshadowed by the mushrooming growth of Atlanta, which soon swallowed large swaths of farmland. Acres of once fertile cotton fields were replaced by large residential neighborhoods, while businesses cropped up along the main thoroughfares. Many of these businesses were multicultural. Duluth's founders could never have foreseen that residents might enjoy a Thai restaurant one day and a Korean restaurant the next. With its place firmly located in one of America's fastest-growing counties, Duluth had to make changes. The old Methodist church was moved to make way for a new town hall. An amphitheater was built to accommodate concerts and festivals. Industrial office parks were constructed close to subdivisions to allow people to work close to home. Condos were built around the town green so that Duluth could return to its roots as a community in which to live, work, and play. Perhaps most emblematic to the history of Duluth is the passenger train depot that stood for so long next to the railroad and represented Duluth's progress. The old depot was moved once before to a city park, but now it has been moved to a nearby railway museum, where it will be cared for by railway enthusiasts. Like Duluth, the depot has been reinvented but with its history firmly stamped in its architecture and the memory of its citizens.

GWINNETT COUNTY, 1920S. In the 1920s, it was still possible to encounter a bucolic scene such as this one in Gwinnett County between Duluth and Lawrenceville. This pasture was part of the Howard Huff farm. After World War II, growth began to engulf counties surrounding Atlanta, including Gwinnett. (GWN 336.)

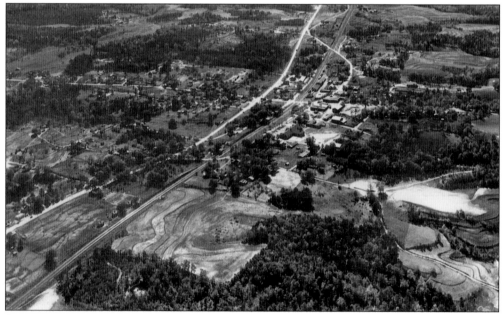

DULUTH BEGINS A GROWTH SPURT. In this mid-20th-century aerial photograph, Duluth is on the verge of a growth spurt. Old Peachtree Road, the meandering road on the right, has been supplanted by a four-lane Buford Highway. (Courtesy of Kathryn Parsons Willis.)

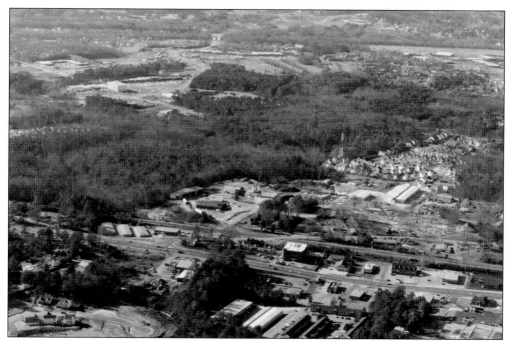

DULUTH IN THE 1990s. Culs-de-sac, office parks, and commercial buildings surround the old town of Duluth in this aerial photograph from the 1990s. Buford Highway, the railroad, and Peachtree Road/Main Street are visible in the center of the photograph. Beyond the grove of trees, residential neighborhoods extend to the Chattahoochee River. (Courtesy of Michael Brown.)

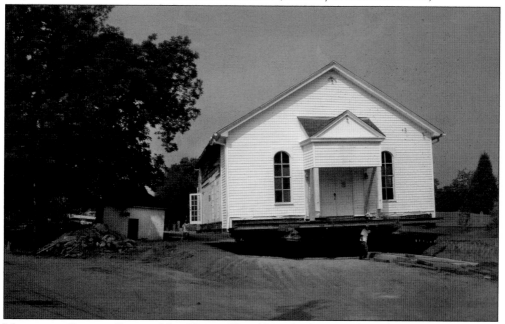

METHODIST CHURCH FINDS A NEW HOME. The old Methodist church, which stood at the top of the hill in the south end of town, was moved farther south to make room for the town hall. Its cemetery, located behind the church, has been fenced and will remain in its original location. (Courtesy of CoD.)

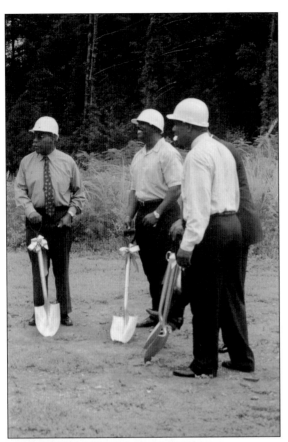

BREAKING GROUND. Ground-breaking ceremonies were held in 2001 for the new Friendship Baptist Church on the Hill. The congregation has grown from 50 to 1,500. (Courtesy of Friendship Baptist Church.)

NEW FRIENDSHIP BAPTIST CHURCH. The new church opened on May 4, 2003, with a celebration attended by congregation members and Duluth citizens. The banner states, "The zeal of the lord has performed it. Isaiah 9:7." (Courtesy of Willie B. Blake.)

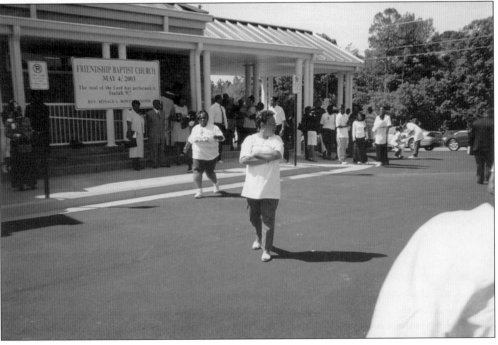

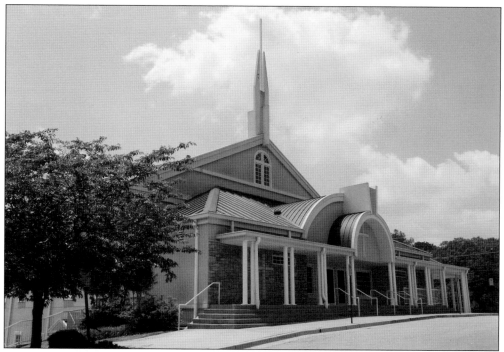

NEW CHURCH. The new structure houses a large sanctuary and meeting rooms, but the congregation has grown to the point that a new ground-breaking is scheduled soon for the Family Life Center. (Courtesy of the author.)

A NEW HOSPITAL. In 2006, a new hospital was built in Duluth to replace the smaller Joan Glancy facility, which now operates as a rehabilitation clinic. (Courtesy of Gwinnett Hospital System.)

DULUTH IN THE 1980s. Downtown Duluth in the 1980s provided shoppers with a hardware store, furniture store, and flower shop. (Courtesy of Kathryn Parsons Willis.)

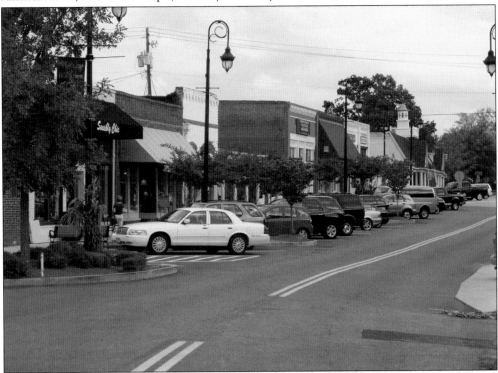

A NEW STREETSCAPE. After a makeover, Duluth has a more modern look. Some older elements were left in place, while newer amenities were added, such as streetlamps that mimic an older style. (Courtesy of Michael Brown.)

PAYNE HOUSE. The Payne House, home to a Duluth merchant in the early 1900s, is now a Montessori school. (Courtesy of Ann Parsons Odom.)

PAYNE-CORLEY HOUSE. The Payne-Corley House was built in 1873, soon after Howell's Cross Roads became Duluth. The two-story structure on three acres was home to the Payne and Corley families. The Paynes operated Payne Brothers, a general merchandise store in Duluth. An old smokehouse, a pump house, and other original buildings are still located on the property. The house is now a special-events venue and a popular location for weddings. (Courtesy of the author.)

A NEW DULUTH. Duluth's broad esplanade, with shops on the right and city hall serving as an anchor, provides a place to walk and play. A new condo development is located behind the shops. (Courtesy of the author.)

KNOX HOUSE. The c. 1900 Knox House, once home to John Knox, Duluth's first mayor, is now a restaurant. (Courtesy of the author.)

FINAL RESTING PLACE. Although the Methodist and Baptist church congregations have moved to new churches, the Duluth Church Cemetery at the south end of Main Street serves as a reminder of the many Baptists and Methodists who lived, worked, and died in this former farming community. The Baptists are on the south side of the cemetery, and the Methodists are on the north side. Just outside the cemetery boundary is the new city hall, providing a focal point for the redesigned community. (Both, courtesy of author.)

www.arcadiapublishing.com

Discover books about the town where you grew up, the cities where your friends and families live, the town where your parents met, or even that retirement spot you've been dreaming about. Our Web site provides history lovers with exclusive deals, advanced notification about new titles, e-mail alerts of author events, and much more.

MADE IN THE USA

Arcadia Publishing, the leading local history publisher in the United States, is committed to making history accessible and meaningful through publishing books that celebrate and preserve the heritage of America's people and places. Consistent with our mission to preserve history on a local level, this book was printed in South Carolina on American-made paper and manufactured entirely in the United States.

This book carries the accredited Forest Stewardship Council (FSC) label and is printed on 100 percent FSC-certified paper. Products carrying the FSC label are independently certified to assure consumers that they come from forests that are managed to meet the social, economic, and ecological needs of present and future generations.

FSC

Mixed Sources
Product group from well-managed forests and other controlled sources

Cert no. SW-COC-001530
www.fsc.org
© 1996 Forest Stewardship Council

Find Your Place in History.